SECRET STAINES-UPON-THAMES AND LALEHAM

Jill Armitage

AMBERLEY

First published 2024

Amberley Publishing
The Hill, Stroud
Gloucestershire, GL5 4EP

www.amberley-books.com

Copyright © Jill Armitage, 2024

The right of Jill Armitage to be identified as the
Author of this work has been asserted in accordance
with the Copyrights, Designs and Patents Act 1988.

ISBN 978 1 3981 1556 9 (print)
ISBN 978 1 3981 1557 6 (ebook)

British Library Cataloguing in Publication Data.
A catalogue record for this book is available from the
British Library.

Origination by Amberley Publishing.
Printed in Great Britain.

Contents

1. Staines upon Thames: the Roman Town of Ad Pontes

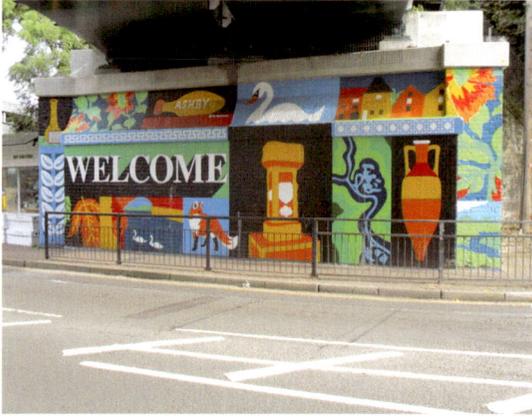

Welcome to Staines. The colourful mural by Nathan Evans on the 2022 refurbished Iron Bridge represents local wildlife, history and industry in simple visual terms.

Follow the River Thames 17 miles west of the centre of London and you reach an area that in pre-history was home to the Catuvellauni tribe living in small settlements on gravel islands in the flood plain of the river. Recent excavations have revealed two Neolithic pits containing chipped flint tranchets, chisel-shaped flint implements, and deer antlers. Use-wear indicates that these would have been working tools in the Stone Age through to the Bronze and Iron Age.

Between October and December 2021, the latest archaeological excavation on the site of a new leisure centre at Knowles Green uncovered more artifacts dating back to the Neolithic period (4000–2500 BC). Three pits contained large amounts of worked flints and a polished stone axe. Next to the Neolithic pits were two well-preserved Bronze Age barrows from between 2500 to 700 BC plus a gold Stater coin from the Iron Age (20 BC–AD 10) and sixty Roman bronze coins.

These finds are especially significant because evidence of pre-history in the area has been disturbed and in many cases obliterated by gravel extraction, reservoir construction, and the motorway network. The flat heathland which had once been the Warren of Staines, then the Forest of Staines, then Hounslow Heath became Heathrow Airport. The name would appear to come from a fourteenth-century document that refers to a man named William Atte Hethe who lived at Hethe Cottage, one of several presumably in a row, thus we have Heathrow. Here, site excavation revealed a late Iron Age open-air shrine or temple of circular shape with a flattened side to the south-east. It had two concentric

ditches, 20 metres apart, and an outer alignment of postholes that probably formed a palisade. Flints, bones and 5,000 pottery shards representing almost 1,500 vessels were scattered around the site and may have been of ritual significance or contained the ashes of the dead. As with most things historical, it is open to various interpretations.

DID YOU KNOW
It could be said that Heathrow was a spiritual runway for the Druid priests to communicate with their dead ancestors, 2,000 years before the first international flight which took place on 25 August 1919 from what was then known as Hounslow Aerodrome to Paris–Le Bourget Airport.

Ad Pontes – The Roman Town with No Ruins

When the Romans arrived in the area in AD 43, they found a series of primitive wooden bridges crossing the marshy flood plains of the Thames, Colne and Wraysbury rivers. In pre-history, river crossings were often pivotal points of ceremonial and economic activity with well-defined trackways leading to the indigenous crossings. The Romans would have used their organising ability, skilled engineers and able craftsmen to develop the place they called Ad Pontes, Latin for 'at the bridges'. They saw the area's full potential and it became a large, significant Roman township, the first upriver of London to have a bridge. Here was the place where the river highway interconnected with the main London road artery to the West Country. Its importance was massive.

DID YOU KNOW
The River Thames – which the Romans called Tamesis – became the highway for commerce, setting the pattern for the next two millennium.

Roman pile-driving techniques enabled them to build improved wharfs and bridges, and experienced shipwrights built stronger barges with improved carrying capacity. Alongside the customary merchandise carried there would have been many additional items brought upriver from around the Roman empire. Pottery would have been of greater variety, and roofing tiles would have been extra to thatching material. The Romans introduced a larger variety of tools for craftsmen and implements for farming. They appreciated the fertile soil of the Thames valley and revolutionised agricultural practices by introducing the wheeled plough. Roman farms in the Thames valley grew up to 500 acres of grain, and the movement of this valuable commodity would have been

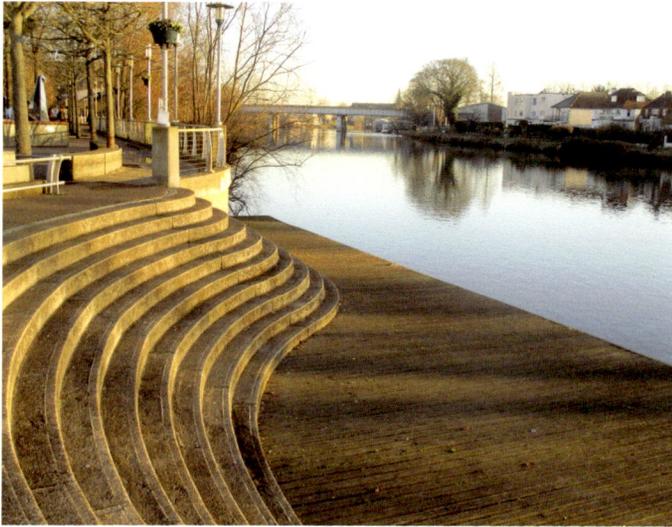

The landing stage where traces of the Roman bridge have been found. The railway bridge can be seen in the distance.

by river. They also grew flax, and fodder for the horses of the Roman cavalry. Whenever possible, these and other similarly bulky goods were transported by river.

Roman barges would have delivered and collected merchandise from this important station at Ad Pontes where a wharf was built directly across the river at The Hythe, a name meaning a landing place or inland port. The Hythe was for many centuries an island and was included within the jurisdiction of Staines. It remained an island until as late as 1754 when changes in the river's course joined it to the opposite bank.

The Roman Bridge

Where a main road crossed a major river, a substantial bridge was required. Good design and construction methods plus robust materials went into building Roman bridges. The abutments probably consisted of massive squared oak beams laid in an interlocking pattern to form large cubes to take and spread the weight. They used pile drivers to ensure that bridge supports penetrated the riverbed to a depth that probably seemed excessive for the time, but this gave ample support for the long baulks of timber with their sophisticated joints on which the roadway was laid.

Roman bridges were built to last but is it possible that – no doubt with numerous repairs – the Roman bridge was still in use in 1228? That's the date of the first bridge mentioned in the archives when King Henry III granted three oaks from Windsor forest for the repair of Staines bridge. Modern development in the town centre has uncovered traces of the Roman bridge in the vicinity of the present landing stage at the rear of the Town Hall.

This significant river crossing would make Ad Ponte 'Staines' a major trading place where you'd inevitably find an inn doubling as a posting house. It's been speculated that the former Bush Inn that stood on the approach road to the bridge may have had its roots in Roman history. The name would support the theory.

DID YOU KNOW
The origin of inn signs goes back to the Romans, who hung vine leaves outside to show that they sold wine. In Britain, small evergreen bushes were substituted and thus many inns took the name 'The Bush'. Early pubs hung long poles or ale stakes that had been used to stir the ale, and if both wine and ale were sold, then both bush and pole would be hung outside.

The Roman Road

The *Iter Britanniarum* is the British section of the itinerary of the Emperor Antonius, recording the stations and distances along the roads of the Roman Empire. This third-century register can be described as the earliest road map of Britain and shows that the principal route connecting Londinium (London) to the west of Britain passed through Ad Pontes (Staines). Here it crossed the River Thames before it continued to Calleva Atrebatum (Silchester) where it split into three routes continuing west: the Port Way to Sorviodunum (Old Sarum), Ermin Way to Glevum (Gloucester), and the road to Aquae Sulis (Bath).

DID YOU KNOW
Modern excavations date the Roman road's construction to AD 47/8, and its width to 7.5–8.7 metres (25–29 ft) wide. The straight line of the road route from Staines to London Wall can clearly be traced on modern maps via the A30, A315, A402 and Oxford Street.

Rediscovering the Romans

The Roman road would have approached Ad Pontes along the A30 London Road off which evidence of a 300-sq.foot Roman marching camp has been uncovered in the former Forest of Staines. It's now under one of Heathrow Airport's runways.

DID YOU KNOW
Although no ruins remain, the route of the Roman road through Staines is now staged to remind us of the Roman occupancy with significant artworks marking the sites of important finds.

Evidence of the Roman road along which all those Centurions marched was found at a site just off the A30 roundabout at the corner of Greenlands Road. To commemorate this find, partly obscured by bushes in the grounds of Centurion House is a 7-metre-tall, self-coloured iron sculpture of Roman shields created by Terence Clark in 1998. When the Romans besieged an enemy fort, they marched forward under cover of their shields in what was known as the testudo or tortoise formation, forming an effective shield wall.

The Romans buried their dead alongside the roads leading to and from their towns. Where High Street becomes London Road inhumations and cremations have been found. When digging the foundations for an extension of the Old Police Station at the junction of London Road and Kingston Road in 2000/2002, excavations uncovered evidence of human burials and cremations, animal burials, pits and ditches dating from a late fourth-century Roman settlement.

On the wall of the Old Police Station car park is a scenic wall frieze by Giorgio Fanelli inspired by the design on a Samian pot in the style of Roman potter Cornutus (AD 128) found on this site.

Across the road during excavations in July 1998 prior to building the current modern office block, two Roman graves and Roman boundary ditches were uncovered. At this point you'll find a most disturbing portrayal of a work-weary horse *by Belinda Rush Jansen.*

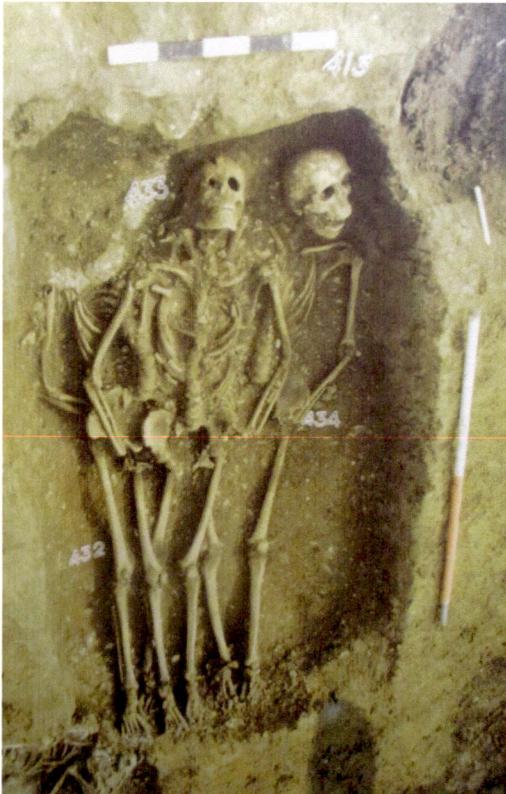

A row of skeletons. (Courtesy of Staines museum)

The boundary ditches would indicate that the Roman settlement stretched from here along the site of the present High Street to the River Thames, which the Romans called Tamesis. It is understood that the present High Street was called Tamesis Street.

We enter the pedestrianised stretch of the High Street, through gateways adorned with four mosaic panels by Gary Drostle. One of these is a charming depiction of a Roman soldier, the name Ad Pontes and the date AD 43.

Between 1969 and 1973, there were a succession of excavations and finds at nine sites on the High Street and Thames Street. Evidence of the Roman road was uncovered when the Elmsleigh Shopping Centre was constructed in the heart of the town. At the site of the Friends Burial Ground there was Roman pottery, wall plaster, tesserae, hypocaust flues, tiles, window and vessel glass. The redevelopment of Barclays Bank in 1970 gave considerable evidence of Roman occupation including the remains of two buildings dating from AD 70 and AD 130–150, Samian pottery, Spanish amphora and the cheek piece of a cavalry helmet dated AD 60. Evidence of a Roman bath house was found

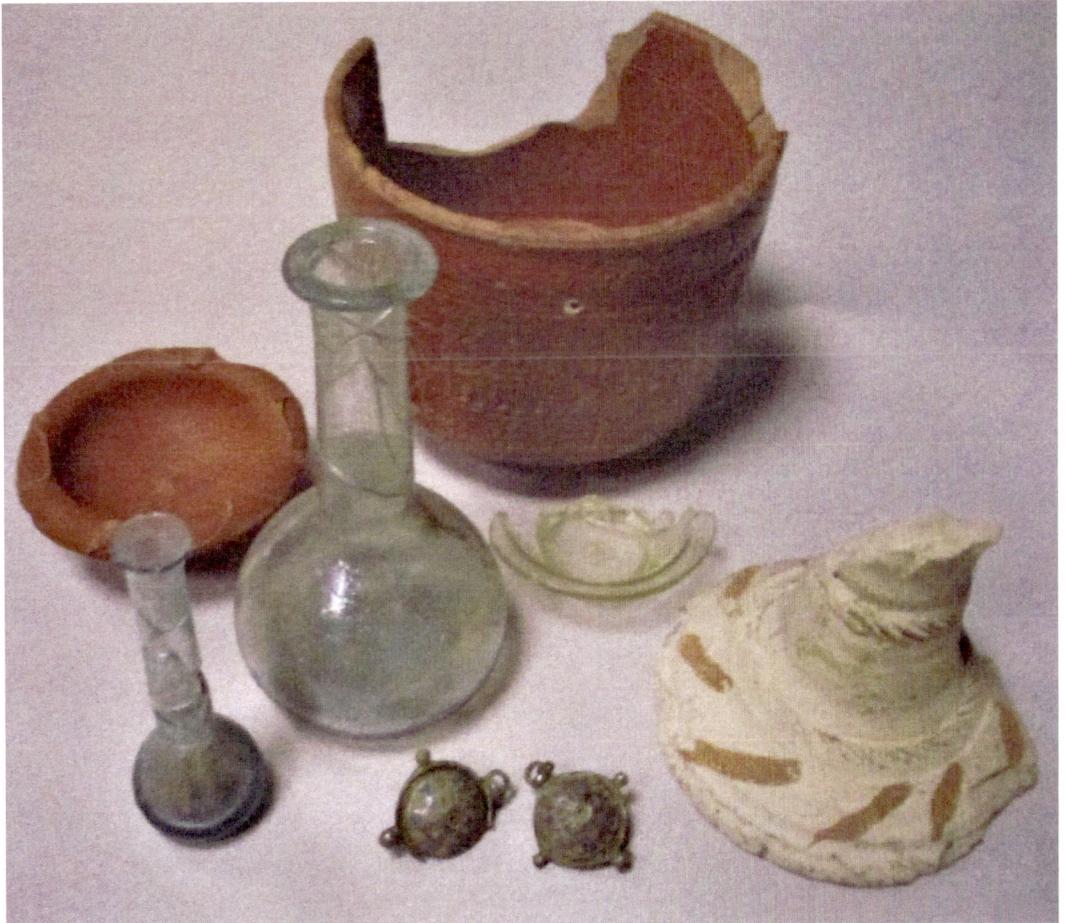

Finds from the excavations at the Old Police Station. (Courtesy of Staines museum)

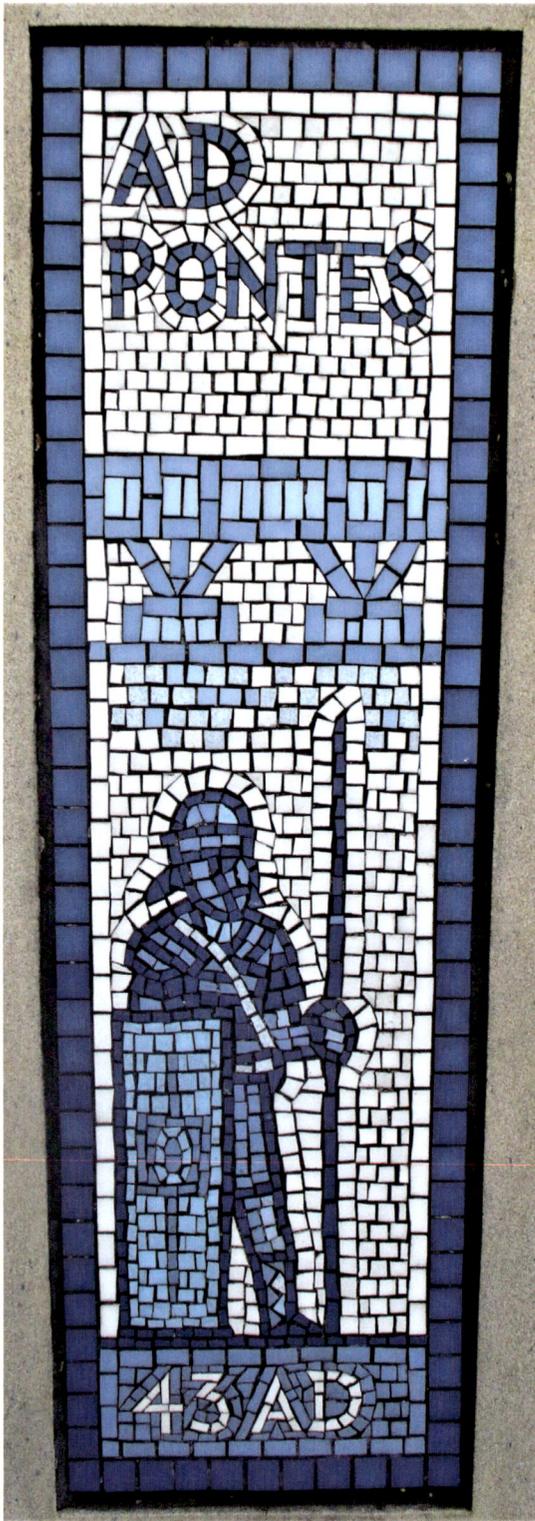

Mosaic of Roman soldier.

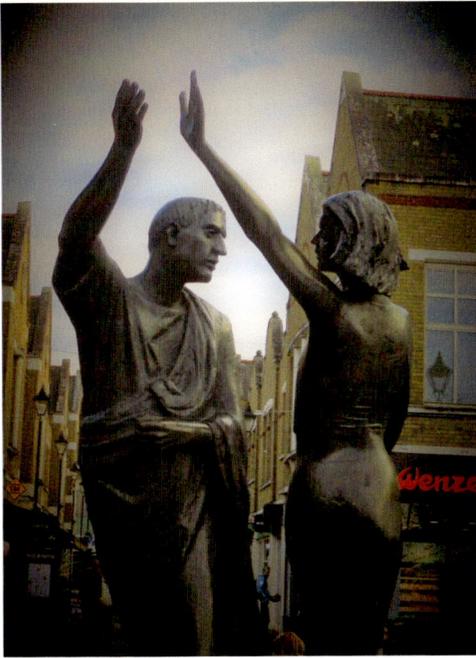

Above left and above right: Artworks in bronze and steel portray the Roman occupation.

Norris Road given a decorative look with colourful umbrellas.

near the Angel Inn. Other sites revealed stone foundations, hearths, ovens, wells, and a second-century red tessellated floor. Fine Samian ware shows high status, imported goods rather than the locally produced rough pottery, evidence that Ad Pontes was a thriving, affluent community. Many finds and a scaled model of Ad Pontes are on display in Staines museum.

Just off the High Street is Norris Road, leading to Two Rivers retail and leisure centre. Here you will find a superb statue of two figures – a Roman in a toga and a modern miss by David Backhouse. It's named *Time Continuum* and symbolises the life and vitality of Staines from Roman times to the present. Rather ingeniously, the figures cast their shadows to the north at midday, making this a sundial.

At the gateway to the riverside gardens is a modern stainless arch adorned with images of special significance to the town. One depicts Roman Staines.

Roman Fort

Roman garrisons were normally housed at forts outside the town, and here on Greenfield Common between Staines and Laleham was a mid-first-century Roman camp recorded by the great antiquarian archaeologist Dr William Stukeley in 1723. Now a part of the playing fields of Matthew Arnold School, Laleham, the upstanding remains that Stukeley found were sufficient for him to identify and draw the typical playing card shape of a Roman fort with its rounded corners, with a secondary earthwork mirroring the first within the shape. The outer shape was gauged to be around 450 feet by 400; the inner around 290 feet by 240. Earthworks projecting out to the east would suggest an enclosed space used for military purposes, although vice or villages grew up around most Roman forts supplying accommodation for camp followers and a market that often developed into a thriving village.

Dr Stukeley's drawing is included in a 1776 book with the caption referring to it as Caesar's Camp. Confirmation of the double set of earthworks was clearly shown through aerial photography of the site carried out in 1933 but further excavations carried out in 1935 and 1949 were inconclusive.

2. Then Came the Normans

There is a dearth of information for many centuries after the Romans withdrew from Britain in AD 410. For Ad Pontes, sometime during this period there was a change of name to Stones/Stanes/Staines. It's believed that it was a prehistoric stone circle where St Mary's Church is now sited that gave the town its name. This is the area where the Anglo-Saxons settled and built a church as early as the ninth century.

We know that the period was marked by frequent warfare, economic, intellectual, and cultural decline, and became known as the Dark Ages. In 1042, Edward the Confessor became the last Anglo-Saxon king and he'd spent most of his early life in exile in Normandy living under the protection of the Dukes of Normandy.

This was a period when many monastic estates were formed or extended, and in 1065, Edward the Confessor gave the manor of Staines, its church and dependent chapelries (Ashford, Laleham, Teddington and Yeoveney) to Westminster Abbey. The royal grant gave the abbey judicial rights over Staines which was administered as a demesne manor. Staines had to provide for, maintain and sustain Westminster Abbey and its eighty monks.

DID YOU KNOW
Staines grew oats, barley and wheat sometimes sown with a mixture of rye and known as maslin. Wheat and oats provided the staple food for man and beast, while barley was used for brewing beer. All these bulky commodities were transported by river weekly from Staines to the storehouses of the abbot at Westminster.

Within a few months, Edward the Confessor was dead (5 January 1066) and there were three strong candidates for the English throne, which was claimed by Harold. Then on 14 October 1066, Duke William of Normandy defeated Harold at the Battle of Hastings, and the Norman victory had a long-lasting impact on England. Within twenty years, William Duke of Normandy had taken a full inventory of his new kingdom, and the famous Domesday Book was produced. Staines appears in the Domesday Book as *Stanes*, held by Westminster Abbey.

In 1100, it was estimated that Westminster Abbey held around 60,000 acres, giving the abbot a power and influence that allowed him to live on a very grand scale. Life was very hard for at least two thirds of the riparian population because the religious orders possessed most of the land beside the Thames, and the remainder was owned by the

> The Abbot of St. Peter's holds
> **In SPELTHORNE Hundred**
> 5 M. STAINES, for 19 hides. Land for 24 ploughs. 11 hides belong to the
> lordship; 13 ploughs there. The villagers have 11 ploughs.
> 3 villagers, ½ hide each; 4 villagers with 1 hide; 8 villagers
> with ½ virgate each; 36 smallholders with 3 hides; 1 villager
> with 1 virgate; 4 smallholders with 40 acres; 10 smallholders
> with 5 acres each; 5 cottagers with 4 acres each;
> 8 smallholders with 1 virgate; 3 cottagers with 9 acres; 128c
> 12 slaves; 46 burgesses, who pay 40s a year.
> 6 mills at 64s; 1 weir at 6s 8d; 1 weir which pays nothing;
> pasture for the village livestock; meadow for 24 ploughs, and
> 20s over and above; woodland, 30 pigs; 2 *arpents* of vines.
> 4 outliers belong to this manor; they were there before 1066.
> Total value £35; when acquired the same; before 1066 £40.
> This manor lay and lies in the lordship of St. Peter's Church.

Staines' entry in the Domesday Book.

Norman elite. Within twenty years, almost the entire Anglo-Saxon nobility had lost their lands and those who were not killed or went into exile were reduced to peasants.

Outlaws and Punishment

When it came to administering the law, the Norman lords had total jurisdiction. They would administer punishment as they saw fit, and punishment was usually hard and brutal. To avoid this, many people, who due to some petty injustice were forced to live outside the law, relocated to dense forests where they could live off the land and hide. They were called outlaws. But even this was considered to be breaking laws as the Norman lords claimed the ground they slept on plus the wildlife and plants they lived off. Forest law, with its own courts and officers, had the responsibility to protect and preserve the venison and vert for the King's pleasure – think Robin Hood and you get the picture.

One such place renowned for its outlaws was the Forest of Staines – sometimes referred to as the Warren of Staines – that stretched from Staines to Hounslow, a distance of 6 miles following the line of the old Roman Road. From 1227 onwards, the dense Forest of Staines was gradually disforested, creating vast open plains and forests that were ideal royal hunting grounds for deer and wild boar, and it was renamed Hounslow Heath.

DID YOU KNOW
Like many open spaces and woodlands, the Forest of Staines was a lawless area, making journeys extremely hazardous. It was home to many who had been deprived of their means of making a living and remained a popular place to ambush travellers and relieve them of their possessions for the next few centuries.

There was a prison in Staines in 1274, and a pillory and cucking stool were provided in 1335. *Cucking* stools or ducking stools were chairs used for the punishment of disorderly women, scolds, witches and prostitutes. The sinner was strapped to the chair, which was fastened to a long wooden beam fixed as a seesaw on the edge of a pond, stream or river where the offender was immersed. Alongside the pillory and ducking stool, there were stocks at Staines in the sixteenth century through to the late eighteenth, all forms of punishment intended to give maximum public embarrassment. There may have been gallows here in the fifteenth century too. Any open space made a good viewing area for the masses that crowded to see such spectacles.

All the King's Horses and All the King's Men

Throughout the centuries, soldiers were regularly billeted at Staines to protect the lawless expanses of Hounslow Heath as well as courtiers and nobility travelling to and from Windsor Castle.

DID YOU KNOW
Built in the eleventh century after the Norman invasion, Windsor Castle is the oldest and largest occupied castle in the world, and it sits on the doorstep of Staines. Over the past 900-plus years, more than thirty monarchs have called it home.

In the Civil War of 1642, the town was occupied by the Royalist army. Staines could have been a battleground and was certainly a war zone because in 1647 English military and political leader Oliver Cromwell encamped his army of 20,000 men on Hounslow Heath, with free billeting in Staines before marching to London. The nuisance of billeting and the constant presence of troops continued and in 1680 Staines and Egham were mentioned as places where the horse-guards usually lodged while the king was at Windsor.

To keep his army intact during the brief reign of James II, in 1686 he established a great camp for 13,000 troops on Hounslow Heath. Having such a huge camp on the doorstep of Staines would have affected the townspeople. A certificate dated 1695 in the Middlesex Record Office refers to sums unpaid for quarters at The Angel and The Anchor for officers and men of Captain Coward's company of dragoons billeted in Staines during the Bloodless Revolution of 1688.

The army had long carried out manoeuvres on the heath and under an 1813 Act of Parliament, a portion of the heath was sold to the government as a military review ground.

Transport Hub

Staines remained an important transport hub, providing a ready supply of post-horses carrying messages between the government in London and the West Country. In 1601, the journey between London and Staines took under four hours but by 1623 it was taking ten

THE
TRAFALGAR WAY
STAINES - 20TH POST-HORSE CHANGE

On Monday 21st October 1805 the Royal Navy decisively defeated a combined
French and Spanish fleet off Cape Trafalgar on the south west coast of Spain.
This victory permanently removed the threat of invasion of England
by the armies of Napoleon Bonaparte.

The first official dispatches with the momentous news of the victory, and the
death in action of Vice Admiral Lord Nelson, were carried to England
on board H. M. Schooner PICKLE by her captain,
Lieutenant John Richards Lapenotiere.

Lapenotiere landed at Falmouth on Monday 4th November 1805 and set out
"express by post-chaise" for London, following what is now The Trafalgar Way.
He took some 37 hours to cover the 271 mile journey, changing horses 21 times.
The 20th such change was made at Staines late on 5th November
at a cost of one pound seventeen shillings and sixpence.

Lapenotiere delivered his dispatches to the Admiralty at 1 a.m. on Wednesday
6th November. The news was at once passed to the Prime Minister and
the King, and special editions of newspapers were published
later the same day to inform the nation.

Erected by Spelthorne Borough Council on 4th September 2005
to inaugurate The Trafalgar Way from Falmouth to London
and
to honour the men of Surrey
who fought for their country at Trafalgar.

The Trafalgar plaque.

hours due to the appalling condition of the roads. Important roads began to be turnpiked in 1727, but the Kingston Road was not turnpiked until 1773. Apart from the streets in the town and tracks across the fields and moors, Kingston Road, Wraysbury Road and Laleham Road were the only roads in the parish before the mid-nineteenth century.

One epic journey is commemorated with a plaque on the side of the Town Hall. Entitled The Trafalgar Way, this is the name given to the historic overland route from Falmouth to the Admiralty in London with the victorious news of the Battle of Trafalgar in 1805. Travelling 271 miles overland from Falmouth to London in a post chaise and four, along the main coaching road took thirty-eight hours and cost £46. There were twenty-one stops to change horses on the way, with a stop-over at the Bush Inn, Staines, at a cost of £1.17s 6p (£1.75p).

Smugglers and Highwaymen on the Heath

Hounslow Heath continued to be home to the marginal, the rebellious and the dodgy. Illegal poaching continued and the heath became a major stopping-off, storage and rendezvous point for smugglers bringing things into and out of London. The vast stabling facilities at the inns in Staines provided a steady supply of horses for these nefarious exploits, rather like the get-away cars of today. One of the main activities of the Staines police force was finding stollen horses and identifying the occasional horse that had been used for illegal purposes. For 100 years, between the seventeenth and eighteenth centuries, this was the classic era of the highwayman, masked up, and robbing wealthy visitors and rich courtiers on the main London to Bath and Exeter roads, and in the centre was Staines.

In 1774, Horace Walpole wrote: 'Our roads are so infested with highwaymen, that it is dangerous stirring out almost by day. Lady Hertford was attacked on Hounslow Heath at three in the afternoon.' Walpole himself was wounded by Captain James MacLaine who was attempting to rob him. His pistol went off by accident, the ball passed through the top of the coach, and Walpole's face was scorched by the explosion. Full of remorse, MacLaine penned a letter to Walpole, apologising for having been compelled by disappointment in a matrimonial scheme to resort to this method of raising supplies. He offered to return any trifles Walpole might value, and sent his sidekick William Conyngham Plunket, 1st Baron Plunket, on his behalf to return Walpole's possessions. MacLaine became so famed for his courteousness while robbing people that he earned himself the nickname the 'Gentleman Highwayman' but was eventually hanged at Tyburn. The 1999 film *Plunkett & Macleane* is based loosely on their exploits.

Another charmer was notorious highwayman Jack Rann, known as Sixteen String Jack. A colourful character in more ways than one, he was known for his eccentric costumes and for the sixteen various coloured strings he wore on the knees of his silk breeches. Shortly before being publicly executed at Tyburn, aged twenty-four, he enjoyed cheerful banter with both the hangman and the crowd, then danced a jig.

DID YOU KNOW
Few highwaymen survived beyond their early twenties. Betrayed for blood-money, or by their own carelessness, most of them ended their short lives on Tyburn Tree, where felons were hanged. When they were dead, their bodies were returned to the scene of their crimes, there to hang rotting as a lesson to others. So plentiful were the gibbets on Hounslow Heath that they came to be regarded as landmarks, and even figured on eighteenth-century maps.

Jack Rann has a rather tenuous connection with Staines. He was married to Letitia Smith, a working-class woman in the Drury Lane district, but after his death, she reinvented herself, became the mistress of the Duke of York and married Lord John Lade, a prominent member of Regency society in 1787. The Lades lived in The Hythe, Staines, where they ran a stud farm. Letitia Lade was a superb horsewoman and a great favourite with the Regent and his set; she was more than willing to join in the culture of excess that they were infamous for. In 1793, the Prince Regent had her portrait painted by Stubbs, sitting astride a prancing horse. It hung in his quarters at Windsor and is still in the Royal Collection at Buckingham Palace. Lady Letitia Lade is buried in the graveyard of St Mary's Church.

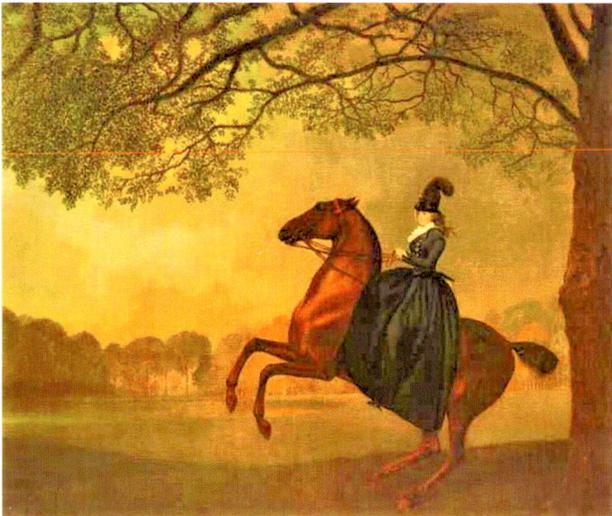

The famous portrait of Letitia Lade commissioned by the Prince Regent.

Historically covering an area of 4,000 acres, between 1788–1818 much of Hounslow Heath was enclosed. In 1919 it became the site of the first civil airport in the country and since the 1940s, Heathrow Airport has gradually been swallowing up more and more of the land. In 1991 around 200 acres of heathland was designated a statutory local nature reserve.

Policing and Ale-conners

The lord's bailiff fulfilled many of the functions of local government in the Middle Ages, and in 1504, two constables were elected. By 1593 there were two constables and four headboroughs (law-enforcing agents) *who had jurisdiction over the whole parish.* Some of the earliest laws were based on beer, which through taxation was an early fundraiser. In 1188, Henry II taxed beer to fund his crusades. Clause 35 of the Magna Carta (1215) decrees that 'There shall be standard measures of wine, ale and corn.' In 1267, beer prices were regulated by the 'Assizes of Bread and Ale' when the drink and the tax was priced according to the cost of grain. To enforce these laws, a rather surprising manorial officer was the ale-conner, who would visit the town's inns and taverns – which in Staines fluctuated between eleven to twenty – to ensure they were serving a good standard of alcoholic drink in the correct measures, and paying the appropriate tax. Ale-conners exercised control over brewers and had the authority to prosecute dishonest vendors.

And here's the sticky bit. Legend has it that ale-conners wore leather trousers. To test the ale, they'd pour some onto the bench then sit in it. If after half an hour their leather trousers were stuck to the bench, it meant the ale had more sugar than alcohol and was sub-standard. Ale-conners were still being appointed annually at Staines along with the constables and headboroughs in 1805.

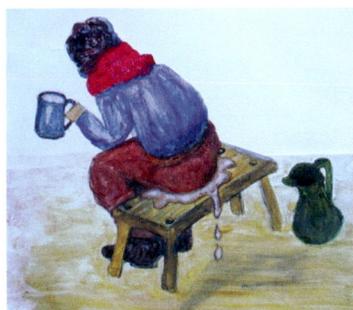

The Ale Conner by Evie Armitage-Chilcott (aged eight).

Dating back to 1808 police records show that the famous Bow Street Runners manned a station on Thames Street. The old parish cage, which stood on the west corner of the High Street and Thames Street, was demolished around 1830, and in 1840 Staines became part of the Metropolitan Police District. In 1876, a building at the road junction where the High Street becomes London Road was acquired for £500 and after many modifications and additions it was Staines Police Station for almost 140 years. In 2000/2002, when the foundations for an extension on Kingston Road was being built, workmen uncovered a rich selection of Roman finds (see chapter 1).

Since the police moved into new purpose-built accommodation a few hundred metres away on Kingston Road, it's now referred to as the Old Police Station. Above the main door can still be seen the word POLICE engraved into the stonework, and the distinctive Victorian blue police lamp, which first appeared in London in the late 1800s, is now mounted on a lamp standard outside the new police station.

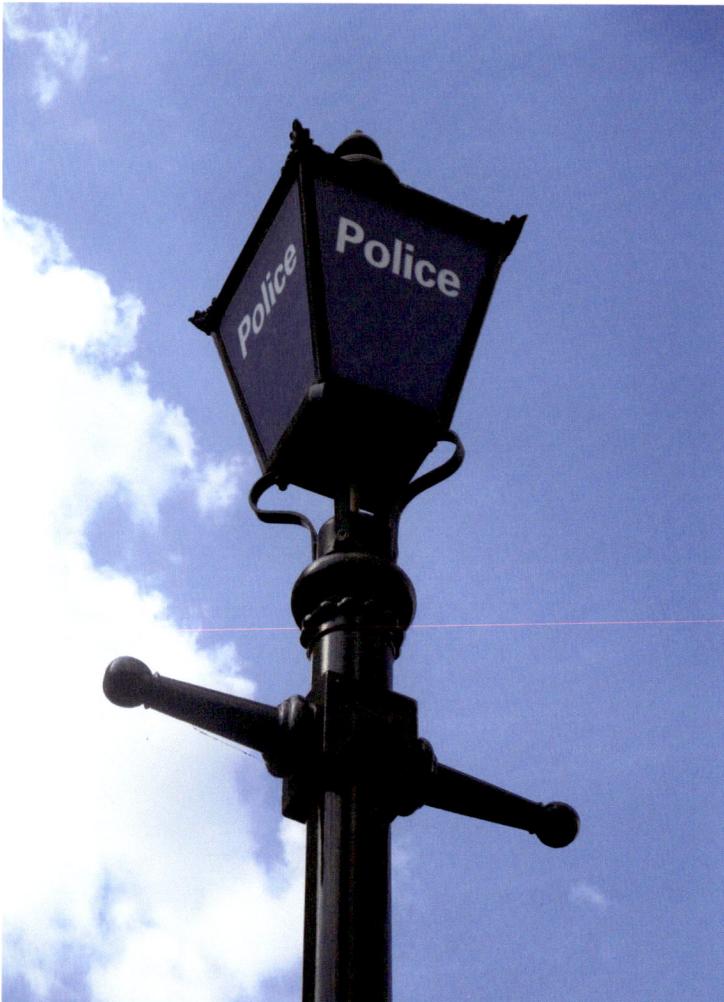

The once familiar blue police lamp.

3. The Royal River – The London Stone – Bridges

After the Norman Conquest of 1066, the rivers Thames, Trent, Severn and Yorkshire Ouse were named the four royal rivers and the Crown assumed responsibility for their upkeep in return for tolls and manorial dues.

In 1192 returning from the Crusades, King Richard had fallen into so much debt, he sold vast areas of Crown land, and on 1 July 1197 signed a charter transferring the River Thames to the Corporation of the City of London for a sum of £20,000. Their responsibility stretched west as far as Staines where in 1285 it erected a stone known as the London Stone. This marked the upper limit of its jurisdiction, the area they controlled from which they could raise taxes.

Staines was chosen because it was the upper limit of the tidal reach, where the water rises and falls with the tide before man-made locks and weirs were introduced – Teddington now holds that distinction. Staines was also the first town upstream of London to have a bridge. In 1619, the City ordered: 'the marke stone at Staynes shalbe removed from the waterfront below Staynes bridge being much decayed and shalbe sett further upon the land and Mr Waterbaylie in his discretion to place it higher'. A Brindley map of 1770 shows the stone had been moved upstream, to what is now Lammas Park.

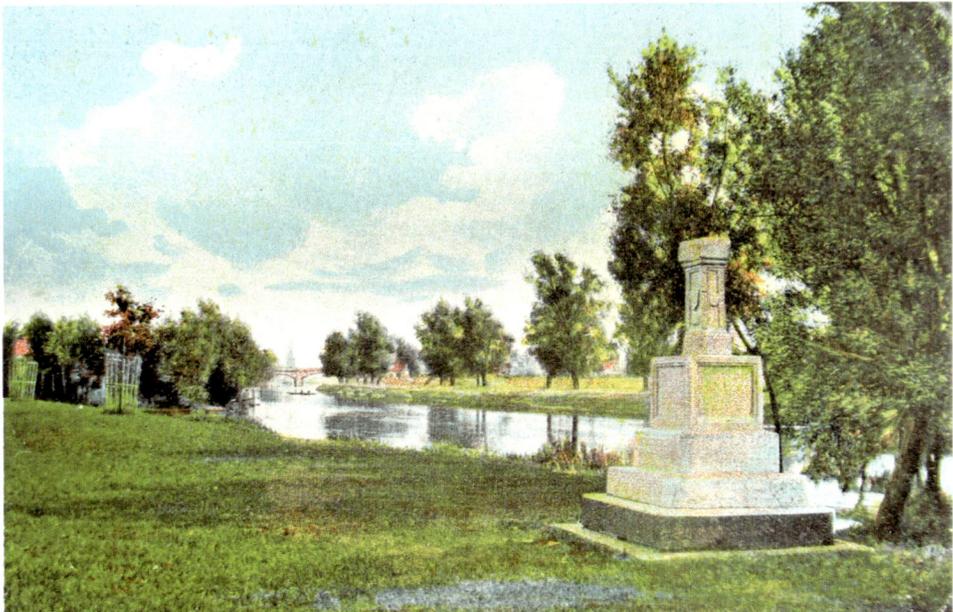

An old postcard of the London Stone.

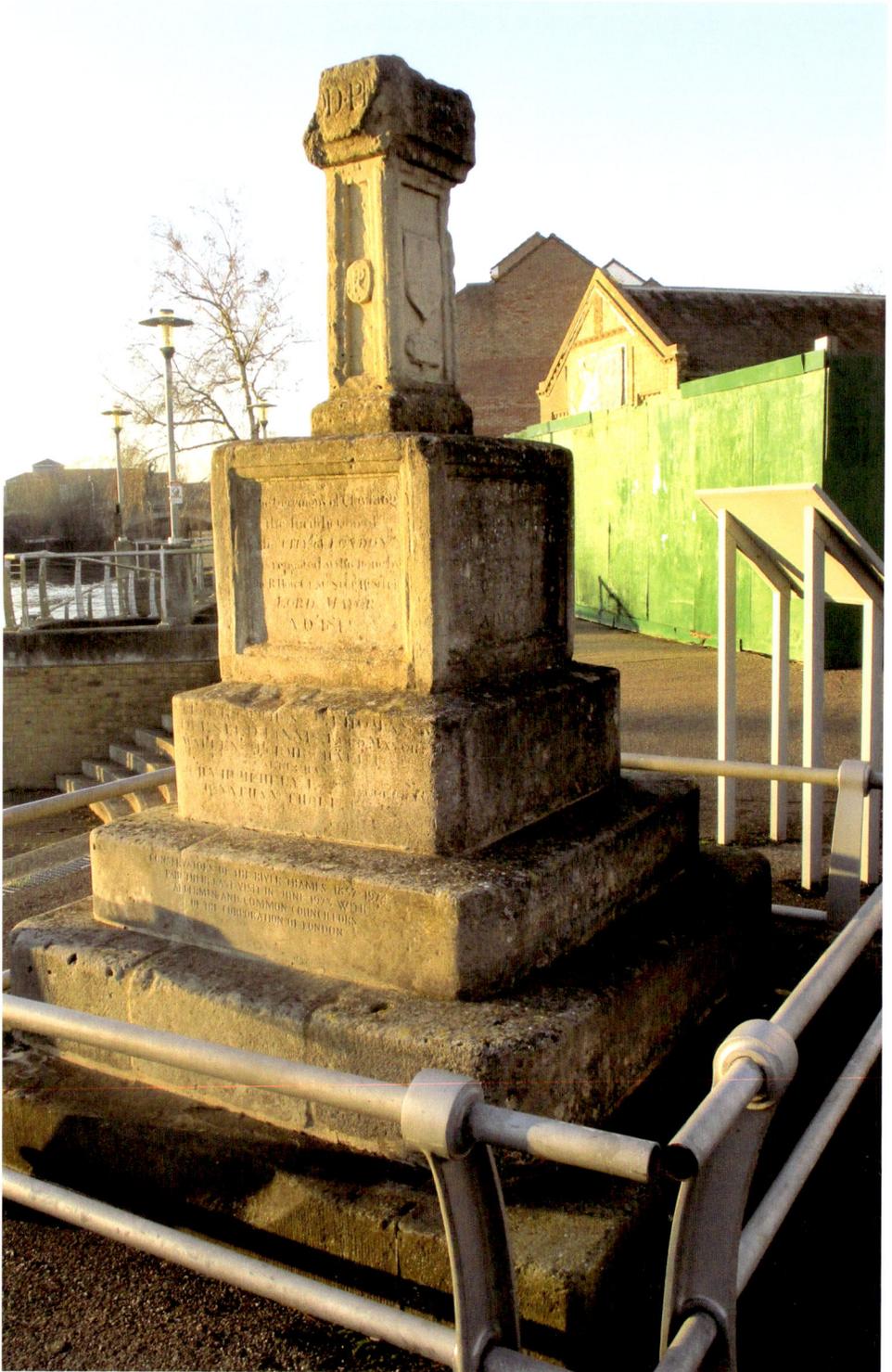

Modern replica of the London Stone.

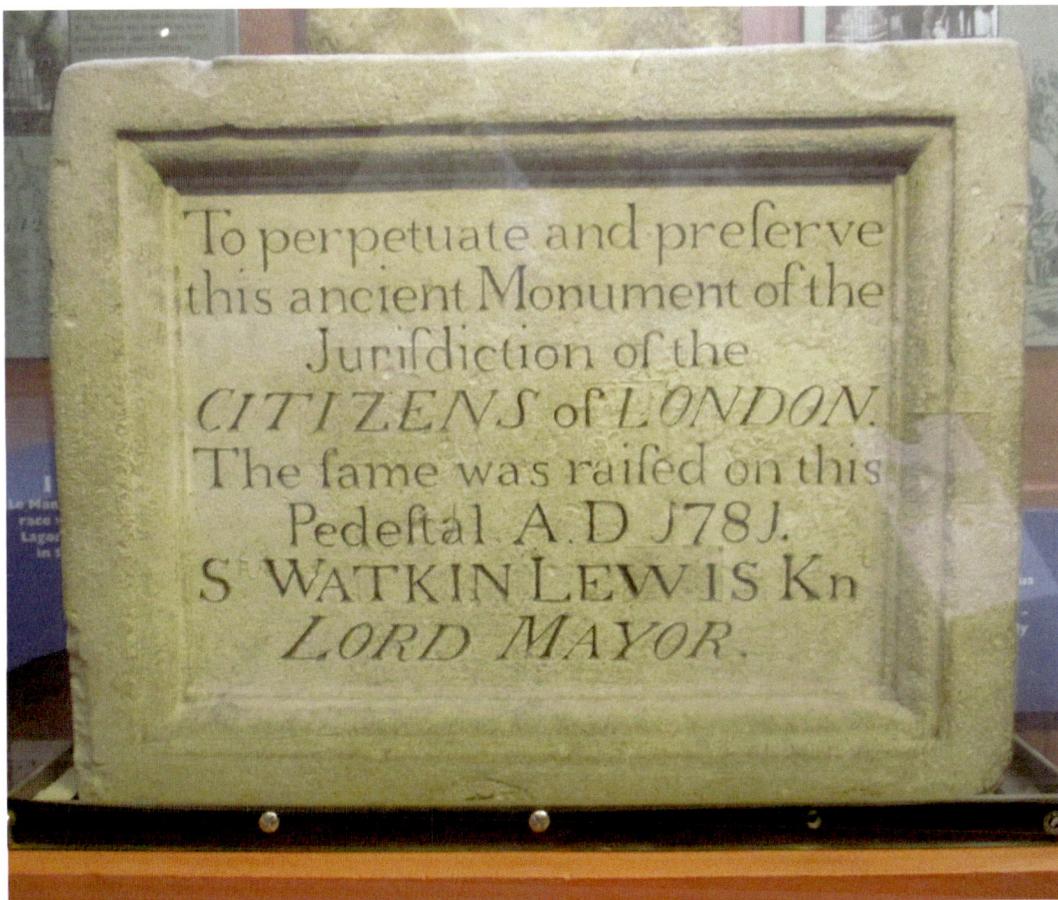

The original base stone in Staines museum.

It remained there until replaced by a replica in 1986. In 2012, this replica stone was moved back downriver to where it is now, near to its initial site behind the Town Hall. You can see the original stone in Spelthorne Museum, behind the library on Thames Street.

The London Stone became embolic of Staines. It's shown in relief on the Old Town Hall turret, on bottles of ale produced by Ashby's brewery, on the coat of arms and several armorial tablets. It's also the name of a character pub on Church Street.

DID YOU KNOW
The London Stone is actually a stack of six layers of stones, of varying dates. The topmost one was reputed to be a Roman altar stone, although its actual origin is unknown. Although badly eroded, on the top section are the words 'God preserve ye City of London AD 1285'.

Ceremony at the Stone

Throughout this period, successive Lord Mayors travelled in ceremonial barges rowed by liveried watermen to touch the stone with a sword to re-affirm the corporation's rights to charge tolls on river traffic and levy taxes on structures such as fish traps. The ceremony included a ritual walk round the stone, the characteristic scattering of coins to the crowd, and an initiation ritual for any sheriffs or aldermen who were attending their first ceremony.

The Illustrated London News of 15 August 1846 describes the ceremony:

The State Barge being moored close to the edge of the meadow a procession of the Watermen, Lord Mayor, the Water Bailiff's eight watermen in full uniform bringing up the procession. The ceremony was commenced by walking round the stone. Alderman Moon then ascended to its summit, and then drank 'God bless the Queen, and Prosperity to the City of London'. Three cheers were then given; the band played 'God save the Queen'; cake and wine were distributed among the party, and small coin was thrown among the crowd. There is an old custom of bumping at the stone the Sheriffs and Aldermen who had not been made 'Free of the Waters'. Accordingly four watermen seized upon Sheriff Laurie... and upon Alderman Moon descending from the stone... they were instantly bumped. Those who had been so served then paid certain fees, and were declared Free Watermen of the River Thames.

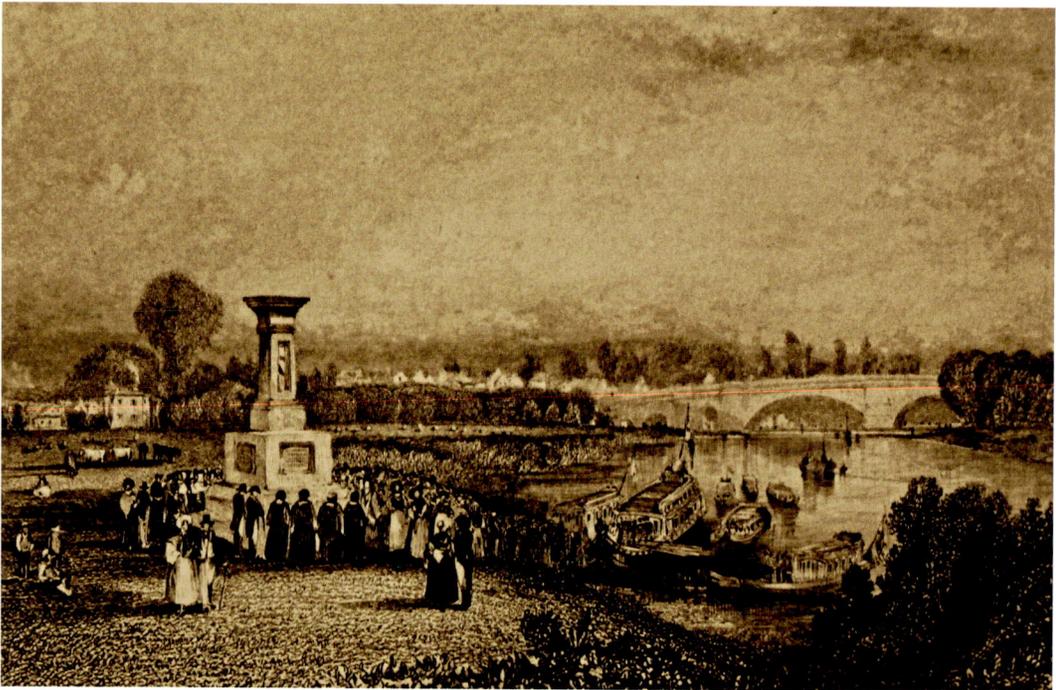

The ceremonial barges moored at the London Stone ready for the formalities. (Engraving in author's collection)

Rights were not relinquished until 1857 when the responsibility for maintaining the river, licensing the people who trade on the river, and protecting the river and waterfront sites from inappropriate development passed to the Thames Conservancy (now known as the Environmental Agency). They took over management of the whole 177 miles from source to sea. The water bailiff, his assistants and all the watermen of the Mayor of London were pensioned off and 700 years of history ended.

Coal Tax Posts

Another ancient practice was the tax on coal imported into London. Originally coal was brought by sea to riverside wharfs all along the Thames from Yantlet Creek (downstream from Graveshead) to Staines. **Boundary marker posts** were erected all along the river to mark the points where taxes on coal were due. By the nineteenth century, however, coal was being increasingly transported by canal and rail, and various Acts of Parliament extended the catchment area to include these new modes of transport, forming an irregular loop 20 miles from the city of London. In 1887, there were 257 coal tax posts recorded in Staines; now you will find four posts and two obelisks, running along the western edge of the Spelthorne Borough.

Entering Staines along the Laleham Road where it becomes Thames Street, on the right just after passing under the railway bridge is a stone obelisk. This was just one of five different types of coal duty boundary posts. The lettering '14 & 15' refers to the regnal years of Queen Victoria in which the tax was renewed. Regnal years are calculated from the official date of a monarch's accession and as Victoria ascended in 1837, this would indicate that the tax was renewed in 1851 and 1852.

DID YOU KNOW
Coal tax money was used to finance public works, including the building of bridges across the Thames as far as Staines. It made Staines bridge free of tolls in 1871, and the locals celebrated by throwing the bridge's toll gates into the water.

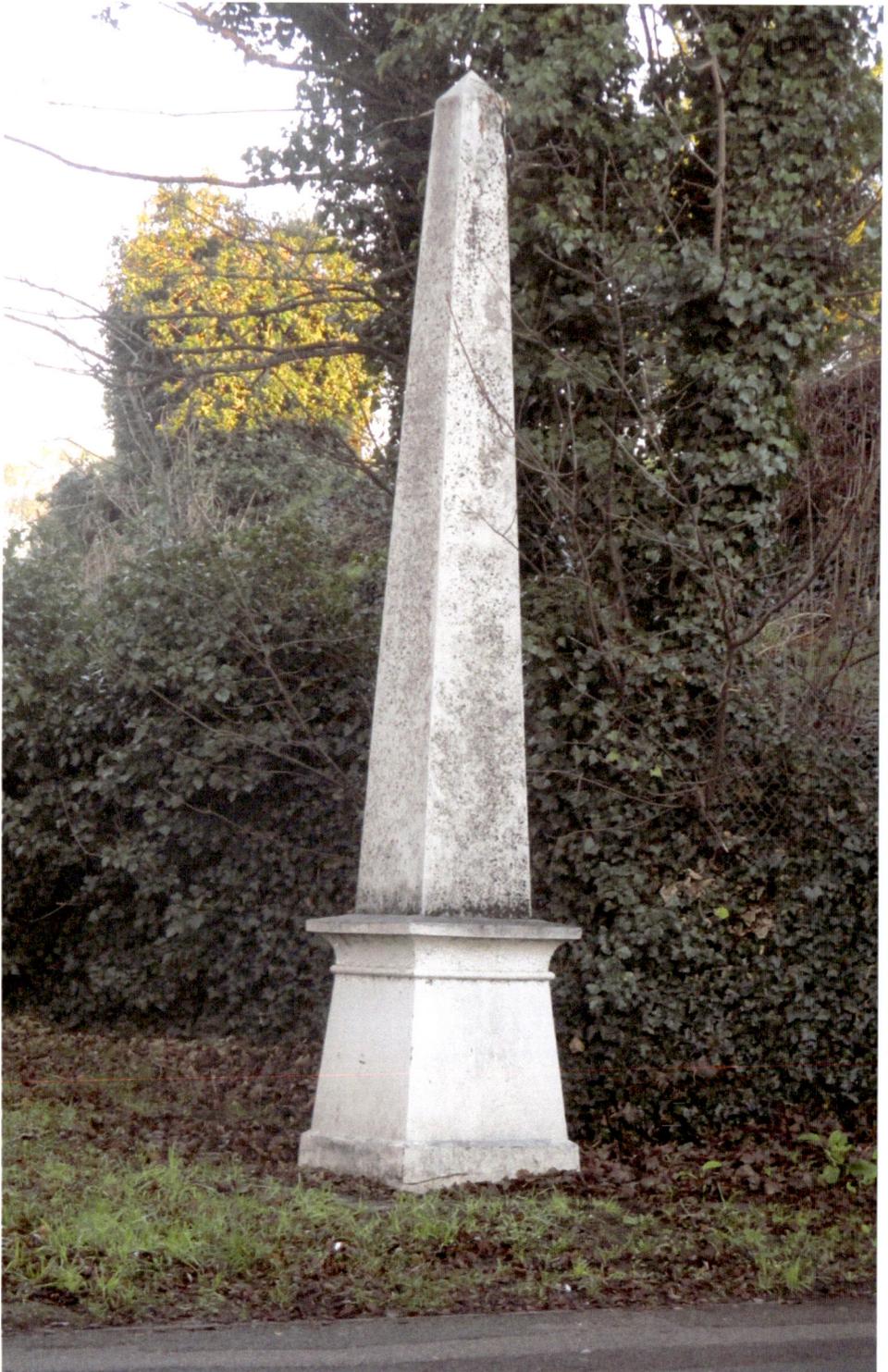

The coal tax obelisk at the junction of Laleham Road and Thames Street.

Bridges

Although there were earlier bridges, the first recorded bridge in Staines was in 1228. This was repaired or renewed when necessary during the Middle Ages. In 1509 an Act was passed, allowing tolls to be taken to repair the bridge, but this was insufficient. By 1619 the tolls were only producing £24 a year, and collection of money in churches in the southern counties for repairing the bridge and causeway was authorised.

In 1688, the wooden bridge was described as being in a ruinous and dangerous condition, yet nothing happened for another hundred years when a new stone bridge was authorised under an Act of 1791. This was not without complications. The river here divided the counties of Middlesex and Surrey and although the magistrates of both counties agreed that a new bridge was necessary, they could not agree on the construction or site. Materials were collected and stockpiled on each riverbank until the two counties could finally agree on what they considered a suitable site close to the old wooden bridge.

Thomas Sandby designed a bridge that consisted of three arches, the centre 60 feet and the two side arches 52 feet wide. It was a good-looking stone bridge constructed in four years and opened in 1797 at a cost of £8,400. But within weeks, the middle piers began to sink when weight was laid on them, making the new bridge a total failure. The old wooden bridge was patched and fixed, to continue in use until another bridge was commissioned.

The High Street merged into the market place before crossing the bridge. Note the old Market House with the turret, standing on stilts on the left, and the pub sign on a pole on the right. It's believed that this was the Bush Inn.

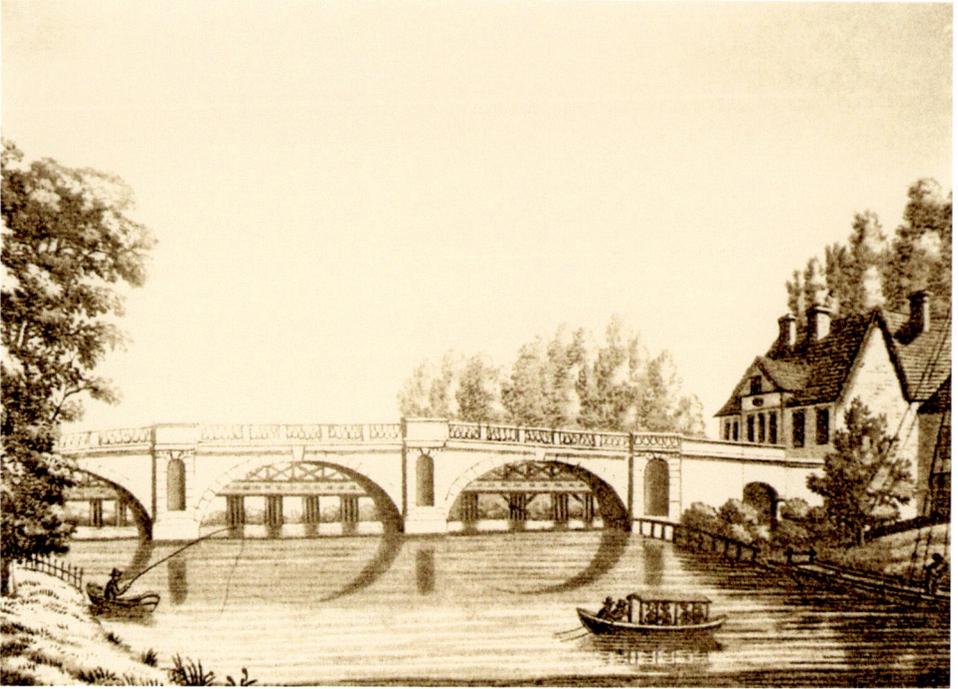

Sandby's 1799 bridge. Painting by Samuel Ireland, 1802.

The Cast-iron Bridge

Meanwhile an adventurous cast-iron bridge had been built to span the River Weir at Sunderland. It had one 180-foot arch that allowed large ships to sail under, and was supported at both ends by high rocky banks. As it seemed that the bed of the river at Staines could not support piers, a similar iron bridge with stone abutments at each end seemed to offer the obvious answer.

Thomas Wilson drew up plans for a bespoke iron arch with a 181-foot span and 16½-foot rise. As it was to be placed in the same position as Sandby's failed bridge, when this bridge was removed, the stone abutments at each end were retained to make the new bridge more cost effective. The final cost was £4,900 and the bridge opened in 1803. The light and elegant appearance of the cast-iron bridge was much admired, and all might have been fine if the bridge builders had taken into account the enormous lateral pressure of the wide, flat arch.

The Middlesex abutment, although appearing to be solid, was hollow to serve the additional purpose of wine cellar of the riverside inn. As carts and carriages began to pass over, the metal arch pushed away the abutment – alias the wine cellar – which slid horizontally backwards. Preserving the upright position, the abutment was strengthened, but no sooner was this done, than the abutment on the opposite bank failed. The iron bridge was clearly unsafe and unsuitable for purpose. With their funds nearly exhausted, no alternative remained but to remove the iron bridge entirely, and patch up the old wooden bridge until another new bridge could be built.

The Wood and Iron Bridge

The decision was made in 1807 to build a wooden bridge strengthened with iron plates and supported by forty-eight piles. Not the most aesthetically pleasing bridge ever designed, nor the most practical as the openings between the piles proved to be too narrow for ease of navigation. It needed constant, costly repair and after twenty years, four fifths of the structure needed replacing.

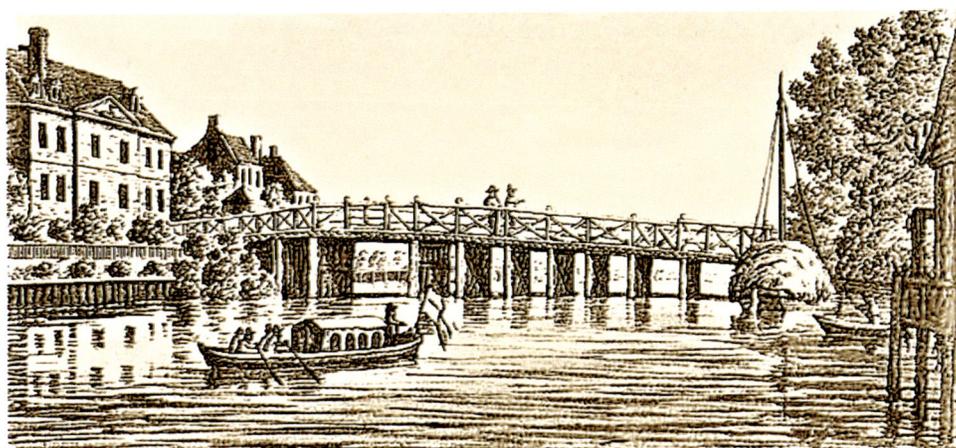

Another bridge unfit for purpose.

Finally the bridge was condemned and a bill was brought into Parliament in 1828/29 to authorize the Commissioners to raise funds to build another bridge. After three failed bridges in 132 years, it was time for a major re-think.

Rennie's Bridge

The next bridge was designed by George Rennie, who insisted on siting it 200 yards further upstream where the riverbed provided better foundations. To accommodate this, the western end of the High Street needed a massive reorganization and that involved a lot of compulsory purchases and demolition of property to provide new approach roads. The ancient Bush Inn was most affected as its site extended all the way from where the Town Hall now stands to where the new bridge was to be built. This was a flourishing business with an annual income of over £11,000. The bridge commissioners offered £4,000 compensation, but the landlord wanted at least one third more. The Red Lion was also on a valuable site and the landlord got compensation of £3,900. Owners of property on Church Street received £500 and landowner Thomas Ashby received £150 to surrender a strip of his pasture so that the new Bridge Street would go through. William Holgate, whose shop occupied another prime site, was offered £1,000 but he wanted more, and so the negotiations continued.

The New Staines Bridge

On 14 September 1830, the foundation stone of the bridge was laid by Prince William, 1st Duke of Clarence. In his honour, the subsequent new approach road was given the name Clarence Street. The new bridge consists of three very flat segmental arches of granite. The middle arch has a 74-foot span. The two side arches each have a 66-foot span and over the towpaths are two arches with 10-foot spans. There are six brick arches each spanning 20 feet, two on the south bank, and four on the north bank, to allow for flood water. The whole is surmounted by a plain, bold cornice, and block parapet of granite, with pedestals for the lamps. The cost of the bridge and approaches was around £41,000. The bridge cost £23,800, the approach roads £7,160 and the removal of the old bridge £11,500.

Prince William returned on Easter Monday, 24 April 1832, as King William IV with his wife, Queen Adelaide, to officially open the new bridge, which has now served almost 200 years.

Until 1871, tolls were charged for using the bridge and this amount was subsidised by the ancient rights of meterage, a tax imposed on coal (see Coal Tax Posts).

During the Second World War, a Bailey bridge manufactured by Callender Hamilton was built upstream to be used in case the main bridge was damaged. It remained in place as a pedestrian bridge until 1959, by which time the main bridge had been modified with the addition of overhanging footpaths on either side of the roadway.

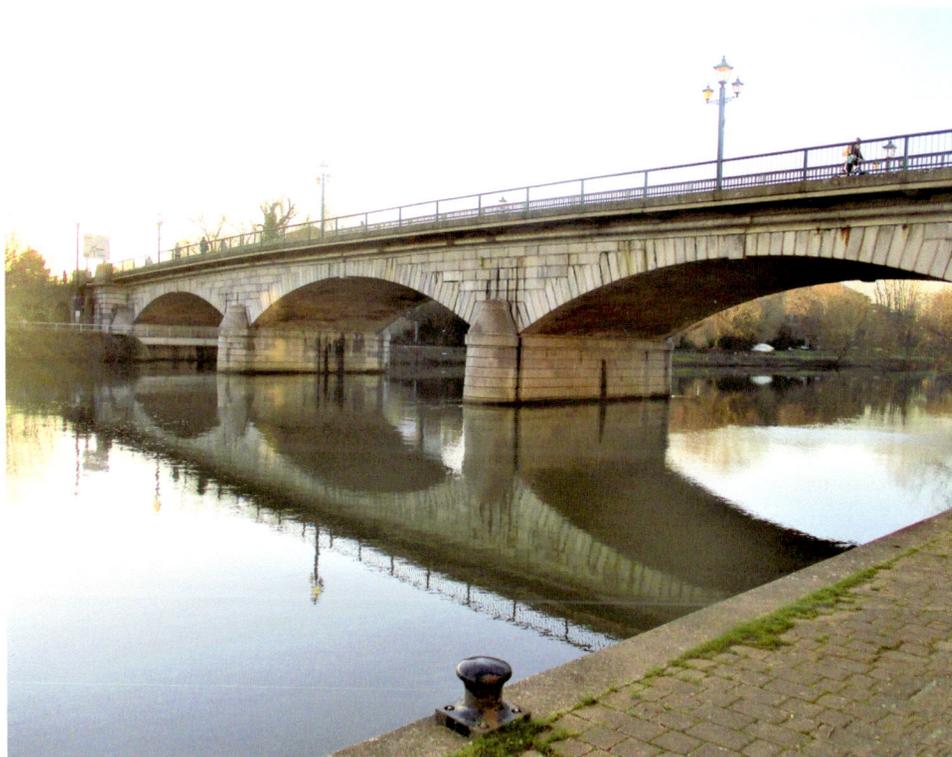

Staines Bridge.

4. The Changing Townscape 1830–1960

The town's population in 1801 was 1,750 and, as in earlier centuries, it would have been a virtually self-sufficient community. Before Staines became engulfed by creeping urbanisation, it was a sleepy market town surrounded by acres of farmland and fields. In the town, domestic dwellings would often have doubled as business premises, and alongside grocers, butchers, and bakers there were specialist shops providing clothing and drapery, hats, shoes and tailoring. There would be bricklayers, glazier/plumbers and tin smiths working alongside coach-makers, coopers, harness makers, cabinetmakers and carpenters.

DID YOU KNOW
William Carpenter began in business in Staines around the middle of the nineteenth century as a carpenter and craftsman repairing and restoring horse-drawn vehicles. According to the Post Office Directory of 1878, Queen Victorian was one of his regular clients.

Due to its riverside position, Staines also had basket makers. Osier beds were numerous along the Thames and an important osier bed near Staines bridge was actually marked on maps. Osier beds, where willows were planted and coppiced to produce withies used for basket making, and fish traps were common in the eighteenth and nineteenth centuries and were usually found on the marshy fringes of rivers and those with small island aits. This crucial industry supplied all sorts of commodities as well as numerous styles of baskets. Nash's shop, established in the 1830s on Thames Street, advertised as 'a basket, sieve, cage and cradle maker'. A basket-making business was established in London Road in 1896 by F. W. Lewis. One of the last items made by him in cane was a bath chair for John Ashby.

DID YOU KNOW
Although basket making declined as cane was replaced by other commodities, the Lewis business continued up to and during the Second World War when C. F. Lewis and a small team made baskets for the Ministry of Defence which the Royal Air Force used when dropping off medical and other supplies behind enemy lines.

Interestingly there was also a hairdresser/parfumier, which would indicate an affluent populace with disposable income. This was reflected in some of the palatial homes dotted along the High Street.

Affluent citizens like the Ashbys had numerous houses around the town including Elmsleigh House, set back from the High Street behind a garden wall. Later the Staines Urban District Council's offices, it was demolished in 1977 and the extensive grounds were used to build the Elmsleigh indoor shopping centre. Opened by her Majesty The Queen on 22 February 1980, it houses fifty-one retail units.

Another Ashby residence, the three-storey gracious Westbourne House with its pillared porch and railings, complete with coach house and stables at the side, was acquired in 1898 by developer and butcher Charles Reeves. Westbourne House was demolished to make way for a three-storey block of shops with living accommodation above. The individual shops with ornate facades cost £7,000, a considerable sum in those days. The Post Office was the first occupant and Charles Reeves opened a butcher's shop which remained until 1931. It's now McDonald's.

DID YOU KNOW
The history of the Post Office in Staines can be traced back to 1672, when records started to name the postmasters or in this case, postmistress Susan Downes. During the years of stagecoaches, local postmasters were often innkeepers. The first proper post office was roughly where the main entrance to the Elmsleigh Centre is now. It then moved across the road to No. 62, where it remained from 1899 until 1931 when it moved to a purpose-built property on the eastern end of the High Street, demolished in 2008.

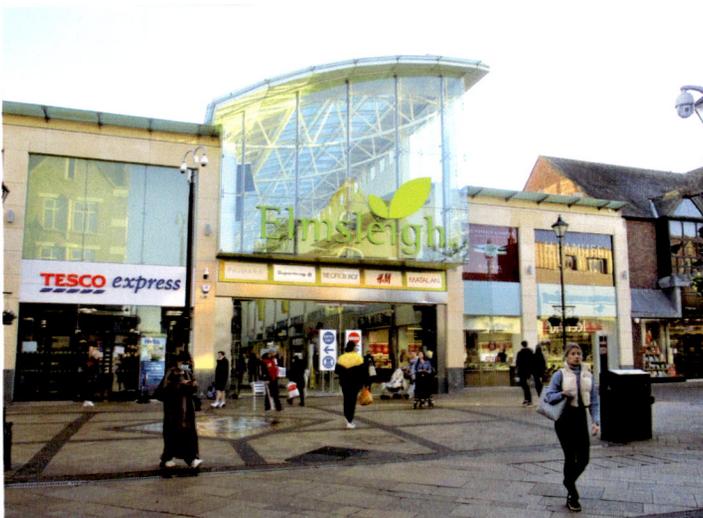

The entrance to the Elmsleigh Shopping Centre on the site of Elmsleigh House.

The former post office with the 1899 date inscribed in the stone between the top two windows.

Initially the High Street was as much residential as commercial. Early photographs show a mixture of graceful residences and tiny shops. Even in 1899, the High Street was still dominated by large private houses. None of these buildings still stand in their former glory. A few survive but have been reconstructed or refaced at a later date, and a large nineteenth-century red-brick, Gothic-style, three-storey building with four gables has been chopped in half. The right side was demolished to build the Elmsleigh Centre.

On the opposite side of the road in 1837, Margaret Pope, a Staines benefactor, built The Mansion, one of Staines' finest houses, replacing an older family home on the site. In the 1890s it was the home of Mr James Pimm and his family. Norris Road was originally the entrance to Pimm's stable yard. This house was demolished at the beginning of the twentieth century to make way for three shops.

DID YOU KNOW
Dr Pope was a Quaker physician to King George III and his daughter Princess Amelia. Dr Pope's treatment of the mentally disturbed king, who spent his last years at Windsor Castle, would indicate that he was a pioneer in the field of mental health.

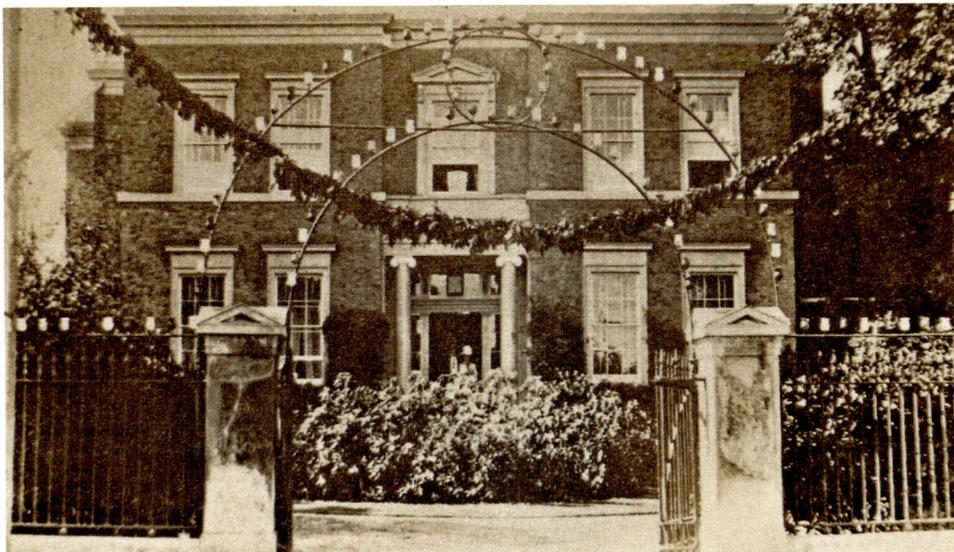

The mansion house.

By the 1830s the number of grocers had increased to twelve, including a number who specialised in tea, cheese and sundries. Trading alongside the confectioners and grocers were watch and clock-makers, haberdashers, milliners, a dressmaker, two book-sellers/ stationers and two saddlers. Willetts the veterinary surgeons started as farriers in 1885. Mr Albert Willets founded the firm in premises on the High Street with an arch leading through to a forge at the back where horses were shod. They remained there until 1976, treating animal ailments and shoeing horses for firemen, police, coal merchants, the Staines refuse cart and other tradesmen.

Three generations of Willets looked after animals owned by royalty, from Queen Victoria to the present day.

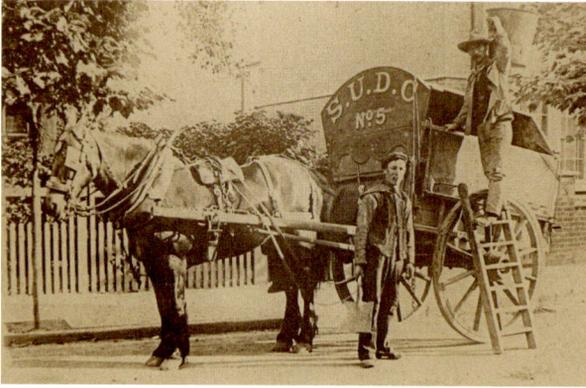

The Staines refuse cart.

The former Debenhams building at the corner of the High Street.

It would be impossible to name all the tradespeople of Staines, but I make one exception. From as early as the 1840, Nos 39, 41 and 43 High Street were occupied by the drapery business of Morford, later trading as Morford and Goodman. One hundred years later, in 1943, the business was bought by Kennards, a member of the Debenham group, and a major rebuild was undertaken. The new building with four storeys and a basement on a 0.66-acre site incorporated the sites of a number of adjacent properties in the High Street and Thames Street and gave nearly 100,000 square feet of shopping space. Completed in 1965, it cost more than half a million pounds, and in March 1973, the name was changed to Debenhams. It's currently still a retails outlet. The biggest store in Staines closed in 2020 and the following year, Future High Street Living (*Staines*) Ltd applied to redevelop the site in a residential-led, mixed-use scheme.

The West End of Town

When a different crossing point was chosen to site the 1830s bridge, this necessitated the building of two new approach roads: Clarence Street and Bridge Street. Until then, Church Street had been the only access road north and now contains some of the oldest properties in the parish. Nos 22 and 24 Church Street are timber-framed and No. 23 is K. W. Dunster Antiques – well worth a browse. Between Nos 19 and 21 is a passage into Gorings Square, which takes its name from a family of butchers who were in Staines from at least 1790.

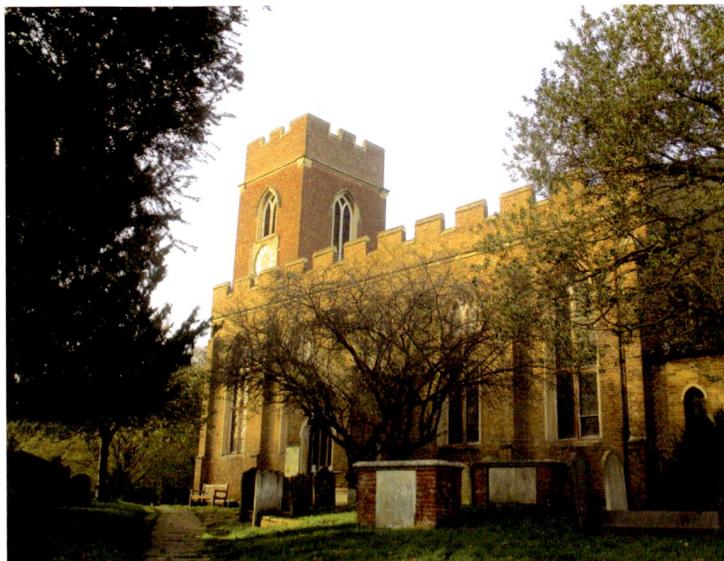

St Mary's Church.

The bridge over the River Colne in Church Street was widened in 1830, and on the wall of the neighbouring house, named Colne View, built in 1828, is a high tide marker.

At the opposite end of Church Street is the church of St Mary stands on a wide spur of land between the discharge of the rivers Colne and Thames. The site would have been a pre-Christian place of worship but the earliest written evidence of a church building is 1179. Historically, the road passing St Mary's to the river was known as Binbury Row, from the Anglo-Saxon meaning 'inside the stockade or settlement'. A large part of this early church collapsed in a storm in 1827 and was replaced by the present Gothic-style church. It cost £3,000. The oldest surviving part of the church is the tower built in 1631, on which a plaque says it was designed by Inigo Jones who is said to have resided for some time in the town.

DID YOU KNOW
As late as 1775 the vicar provided a bull and boar for the parish. It's assumed these were stud animals to serve the local cows and pigs, not for an annual barbeque.

Inside the church are two remarkable stained-glass windows. The nineteenth-century window behind the altar is in memory of Augusta Maria Byng, the governess to the Prussian royal children. In later life she was a resident of Binbury Row, Staines, and is buried in the churchyard. The inscription on the ornate headstone of her grave reads: 'This stone is placed in affectionate and grateful remembrance of many years of devotion and faithful service by Frederick William Crown Prince of Germany and Prussia and

Victoria Crown Princess of Germany and Prussia, Princess Royal of Great Britain and Ireland, and their children.'

The other remarkable window marks Staines' worst tragedy. The nearby presence of Heathrow Airport is normally overlooked but on 18 June 1972, a scheduled passenger flight to Brussels crashed three minutes after take-off, killing all 118 people on board. The aircraft just cleared high-tension overhead power lines and the King George VI Reservoir before it crashed to the ground on a narrow strip of land immediately south of the A30 London road. A few hundred yards further and it would have crashed into the main shopping centre of Staines, where destruction and casualties could have been colossal. There is now a circular seating area and commemorative garden near the end of Waters Drive in the Moormede Estate, close to the accident site. An annual memorial service is held at St Mary's Church on 18 June, and a stained-glass memorial is located in the church. The window was designed by Artemis Decorative Glass (of Staines) and depicts a dove in flight soaring above a landscape of trees. The window is framed by stars, each star symbolising one of the 118 passengers and crew who lost their lives.

A plaque on the Swan Arch commemorating Staines air crash.

Staines Market and Fair

The market place at the head of the High Street had clustered around a Market House probably since the days of its formation in 1218. The Market House was described as a small brick building of two storeys with a spire, situated in a miserable and low thoroughfare known as Blackboy Lane which ran down to the river (see Dunston House for story of Blackboy Lane). Not only did it serve as a Market House, it was also used as a court for official purposes too.

DID YOU KNOW
With plague raging in London, in the autumn of 1603 Sir Walter Raleigh was indicted before Commissioners and Middlesex jury at the Market House, Staines. Sources claim Sir Walter Raleigh was tried here, but this is not correct. It was here he was committed before his trial at Winchester.

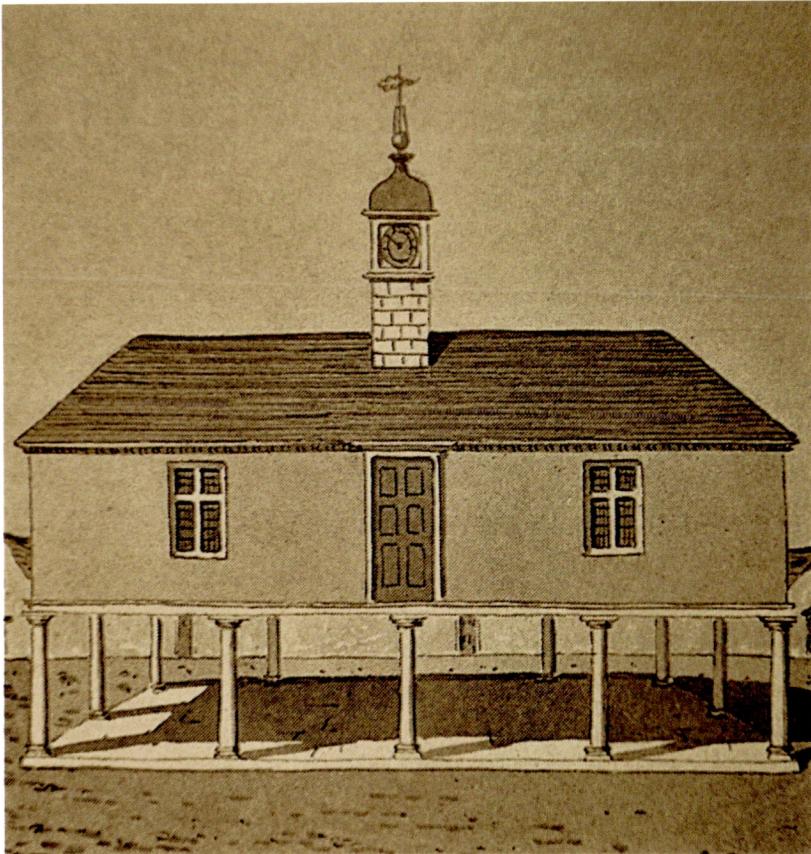

The Market House.

The weekly market which started in 1218 has continued with a few breaks for eight centuries.

In 1228, Staines was granted the right to hold a four-day fair at Ascensiontide. In 1241, the date of the fair was changed to 7–10 September and by 1772 a second fair was also being held in May. Colourful gypsy caravans, stalls selling food and drink, swing boats, round-abouts, boxing booths and all manner of sideshows were crammed into the High Street. The fairs became a major festival often condemned for the drunkenness and immorality they encouraged, but they also served a useful purpose.

Because so many people gathered at a fair, it quickly turned into the major place for matching workers and employers. Prospective workers would gather in the street or market place, often sporting some sort of badge or tool to denote their speciality. Shepherds held a crook or a tuft of wool, cowmen brought wisps of straw, dairymaids carried a milking stool or pail and housemaids held brooms or mops – this is why some hiring fairs were known as mop fairs. Employers would look them over and, if they were thought fit, hire them for the coming year, handing over a small token of money, known as the 'fasten-penny', usually a shilling (5p) which 'fastened' the contract for a year. At the end of the year, the employment could be terminated. Mop fairs in Staines were abolished in 1896, but they continued as pleasure fairs.

The Market House became redundant when the market was discontinued in 1862 and in 1872, this and neighbouring buildings were demolished to form the Market Square and at its heart the town needed a new Town Hall. A competition was held for the best design, and the winner was architect and District Surveyor of East Hackney John Johnson. It is an ornate, two-storey, white-brick and stone building surmounted by a steeply pitched roof behind a parapet in a Flemish Renaissance style with Italian and French motifs. There's a central clock tower flanked by small corner towers. It took nine years to build and was completed in 1880, at a cost of £5,000.

DID YOU KNOW
The Town Hall clock by Gillet and Johnson of Croydon has three faces. The one facing the Market Square has two XIs for the hours 9 and 11.

Riverside Gardens

On the site of the former Holgate's Wharf below the railway bridge that crosses the river, in 1897 the Jubilee Gardens were laid out to mark the Diamond Jubilee of Queen Victoria.

They were extended and renamed the Memorial Gardens after the First World War when the war memorial was unveiled by George Bingham, 5th Earl of Lucan, in 1920 to commemorate those locals who gave their lives during the First World War. In 2003, a plaque was added to remember those who gave their lives during the Second World War. The Memorial Gardens got a name change and renovation in 1997–2002 when it became the riverside gardens, and the war memorial was transferred to the market place. It now

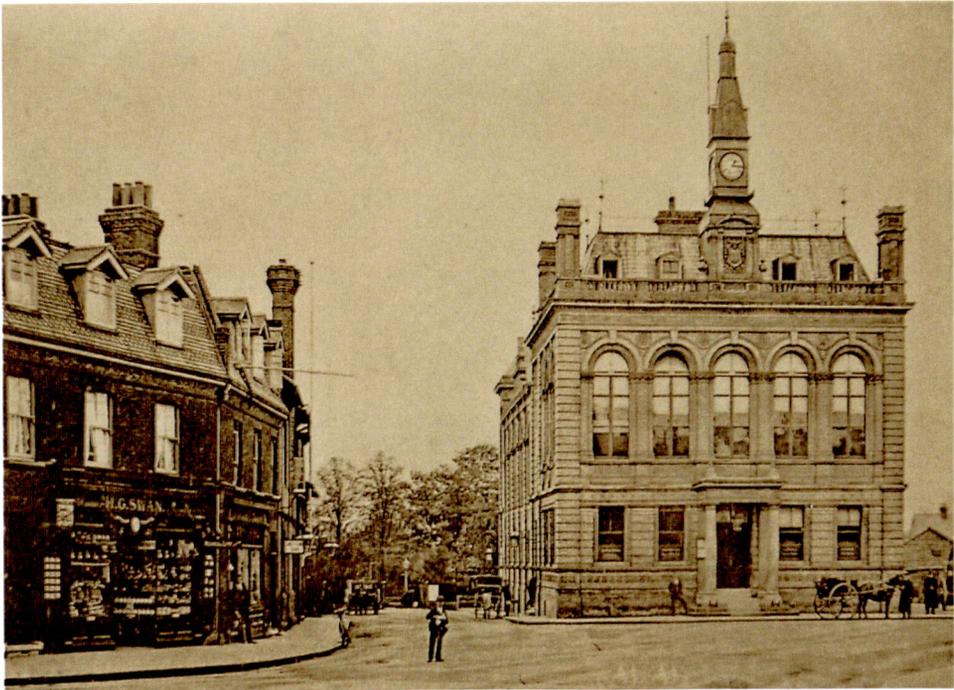

The Town Hall.

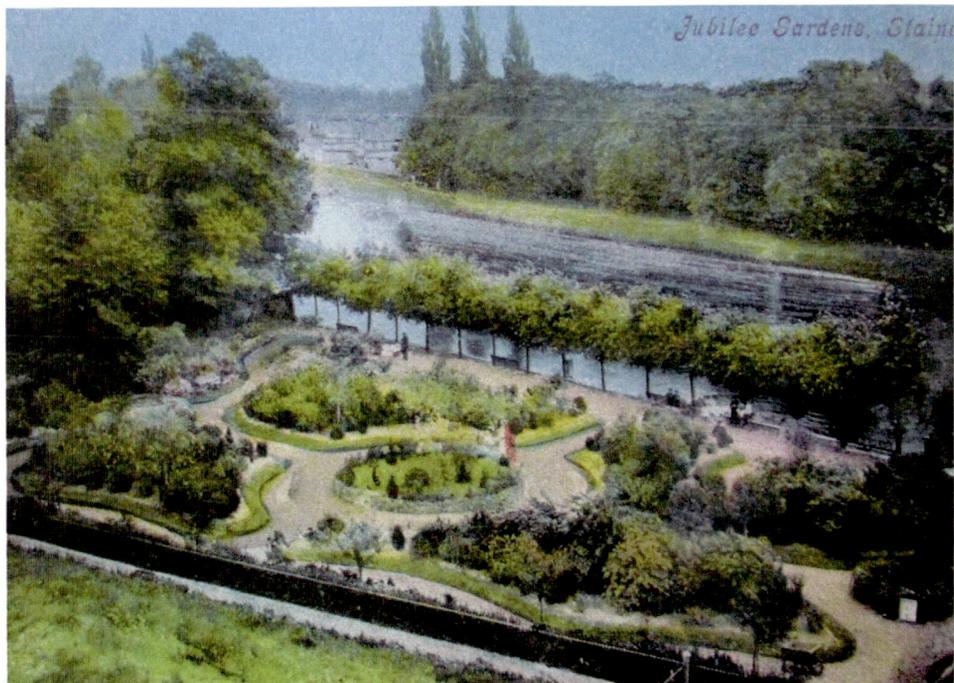

An aerial view of the Jubilee Gardens.

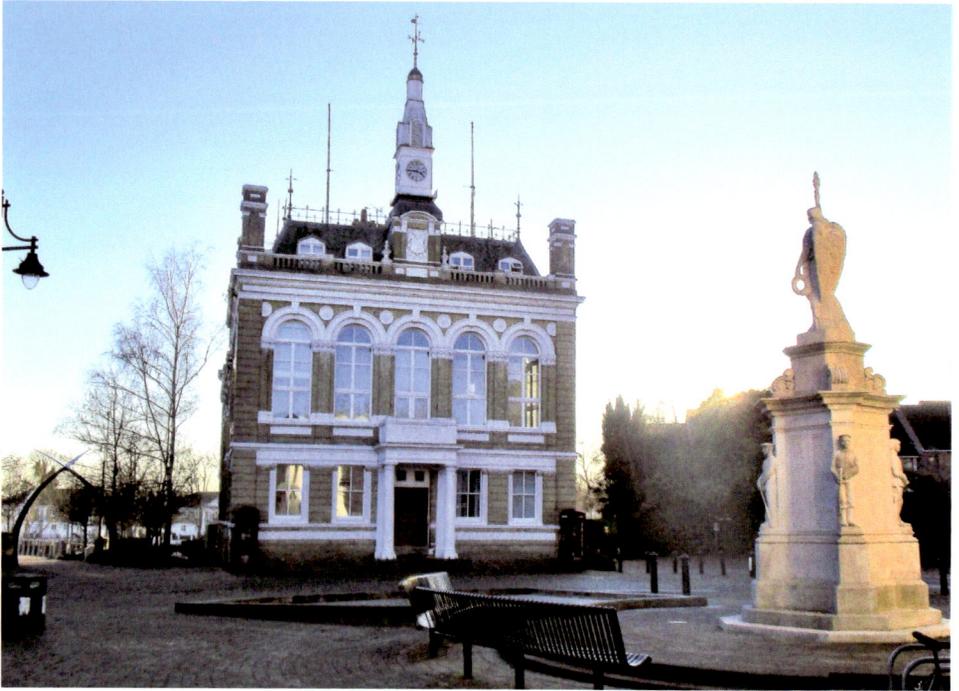

Staines Town Hall with the War Memorial on the right.

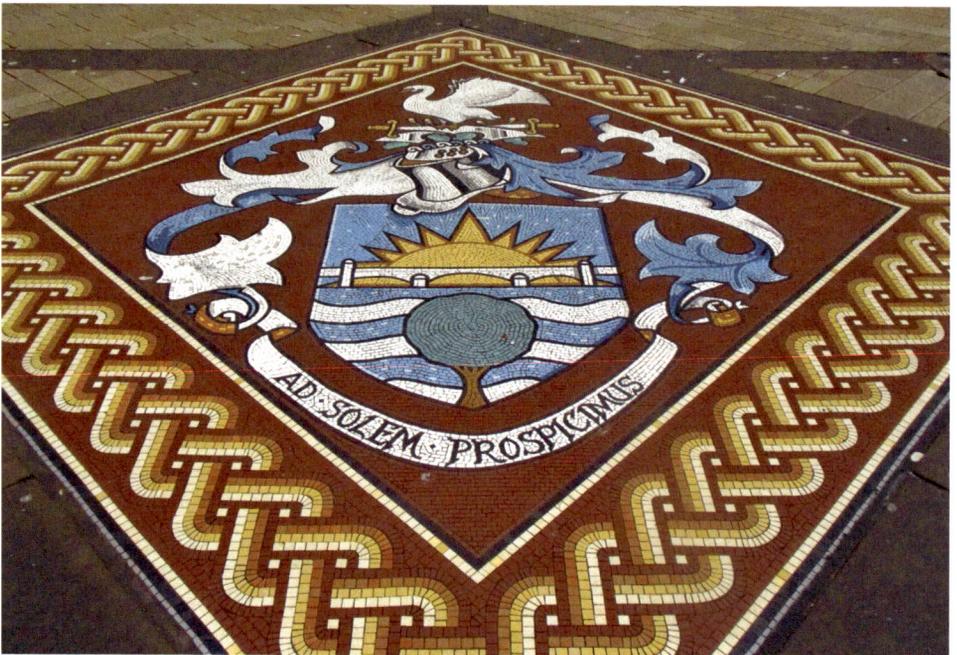

This mosaic floor in the High Street marks the spot where a similar 2,000-year-old mosaic floor was found.

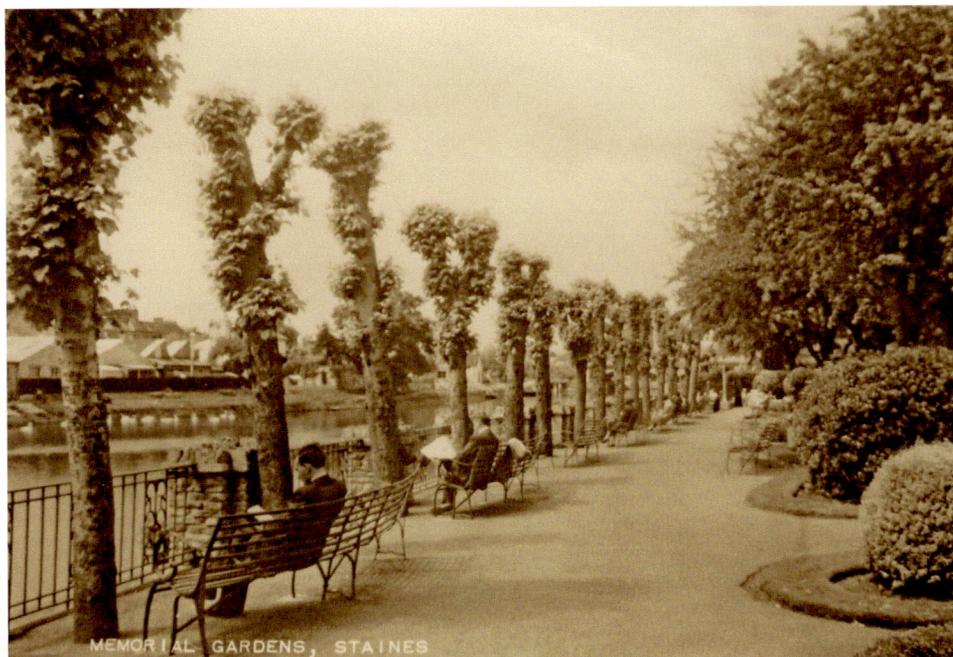

Staines riverside gardens.

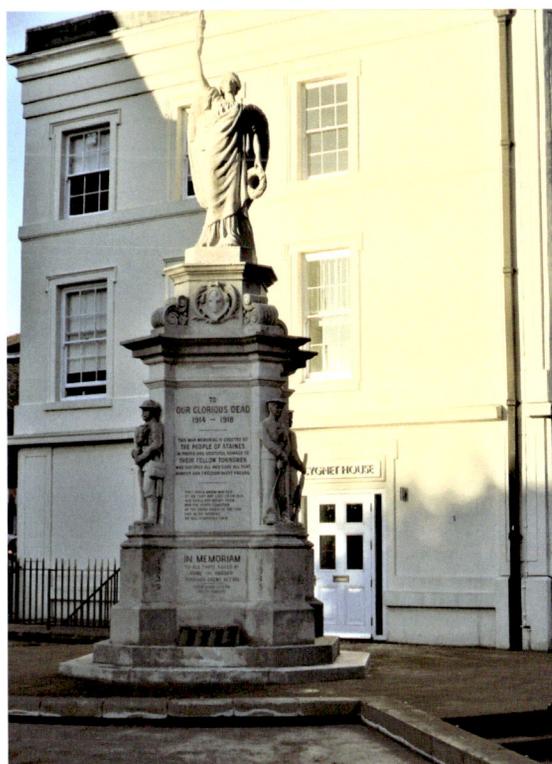

Staines war memorial.

stands almost where the stone cattle trough and drinking fountain stood marking the junction of the High Street and the market place. This now stands at the opposite end of the pedestrianised section of the High Street. At its former site it had a short gas lamp on top with a sign pointing to the Fire Brigade Station, set back to the right of the Town Hall, and built at the same time.

After the fire station moved to Ashford in 1962, the building was used as a market store, then modern archaeological excavations in Staines prompted the need for a place to display them, and from 1980 to 2003 it was Spelthorne's first museum. A major exhibit was the 1738 Parish Fire Engine.

At the end of 2003 the Old Fire Station was sold as part of the Old Town Hall regeneration, and the museum's contents went into storage until finally, in October 2006, the new Spelthorne Museum, with its entry through the library, was opened by television presenter Michael Aspel.

High Street – Changes

In 1911, there were 161 shops and shortly before 1951 there were between 400 and 500. With the increase in motor cars, it seemed that Staines' strategic position where the Great South/West Road crosses the River Thames was causing insurmountable traffic problems in the centre of the town. It was decided that to remedy this, the configuration of old street patterns and narrow intersections, anything that obstructed traffic flow and anything not in keeping with the new alignments had to go. This meant that awkwardly sited ancient buildings, such as the old traditional shops, the 1837 classical-style Congregational chapel, and the sixteenth-century timber-framed White Lion pub, were sacrificed to the bulldozer to make way for department stores on new, traffic-friendly alignments.

But this brought only temporary relief from the difficulties of congestion and the confusion of vehicular and pedestrian traffic. Next, the High Street became a one-way system. The Market Square became traffic-free in 1990 when the adjoining development was completed but it was to be another thirty years before a pedestrian-only High Street was created.

Between 1972 and 1976, Staines Urban District Council and the local magistrates' court moved out of the Town Hall to new offices at Knowle Green. One hundred years of administration here had ended; the building was considered superfluous and it was only saved from demolition by just one vote.

DID YOU KNOW
The Town Hall became the venue for many public events, including boxing tournaments, the local archaeological group, opera and stage plays. Famous rock bands who played here during the 1960s and '70s included The Who, The Yardbirds and The Jaywalkers.

It was used for the court scene in the 1982 film *Gandhi*, where Judge Bloomfield sentences Gandhi to six years' imprisonment for sedition. It also featured in the 2002 film *Ali G Indahouse*.

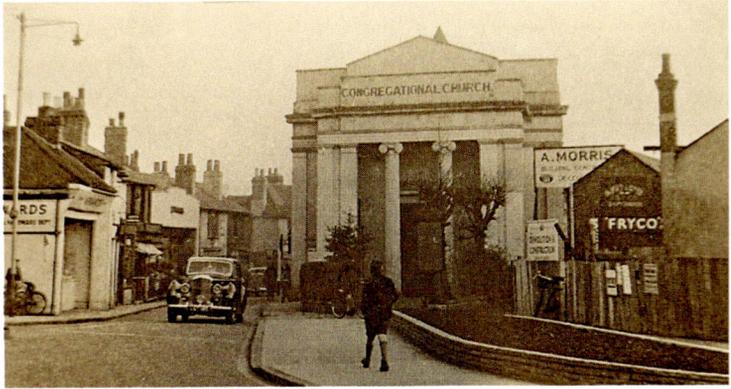

The Congregational chapel had to go.

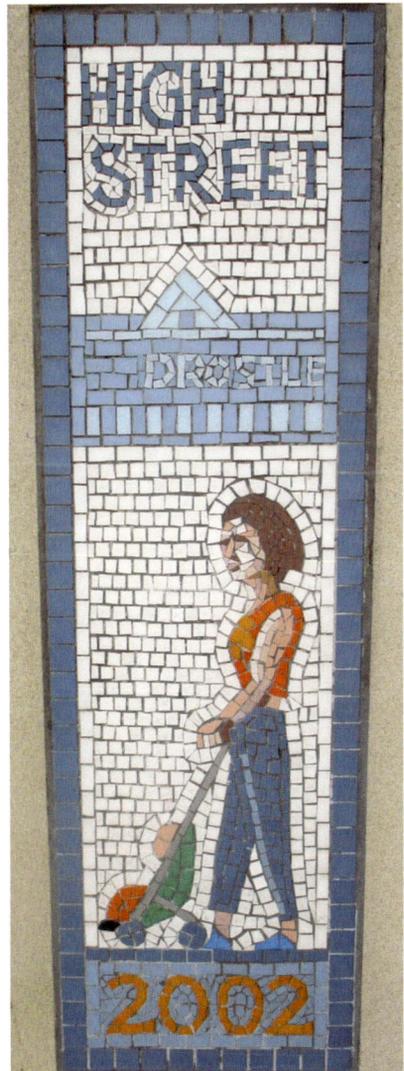

The Lower section of the High Street after it was pedestrianised.

The lower section of the High Street before the road was widened.

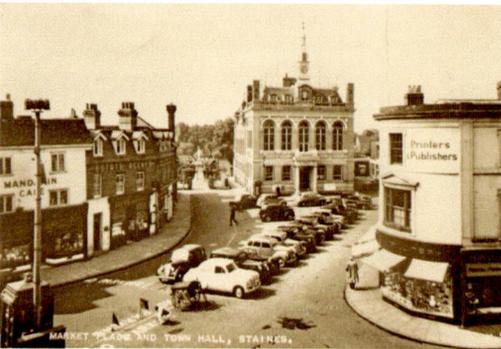

The market square was not traffic free until 1990.

The Town Hall opened as a new Arts Centre in 1993, officially opened on 15 April 1994 by actor and director Kenneth Branagh. In 2004 the building became a 'Smith & Jones' pub and is now residential.

It was the Anglo-Saxons who divided Britain into thirty-five shires that the Normans renamed counties. Staines was part of Middlesex with the Thames providing the boundary with Surrey until in 1965. Middlesex vanished in a bureaucratic puff of smoke and Staines became part of Surrey. Then in 1974, Staines Urban District Council conjoined with Sunbury UDC and formed the Borough of Spelthorne.

The newly formed borough needed a coat of arms, so they incorporated elements from the shields of both towns. Staines' motto, *'Ad Pontes Prospicimus'*, and Sunbury's motto, *'Sol et Pastor Deus'*, became *'Ad Solem Prospicimus'* – 'we look forward to the sun' – illustrated with Staines' bridge and Sunbury's sunburst.

The second half of the twentieth century was a time of transition for Staines as it changed from an industrial town with a Roman backbone to a town buzzing with commerce and vitality. The town centre had a major revamp with ambitious shopping precincts, offices and homes. Few vestiges of the past were retained as Staines reinvented itself with a make-over on a gigantic scale, gaining the prestigious Town Centre Environmental award in 2003 in the process. Officially the name was changed to Staines-upon-Thames in May 2012 to promote its riverside location. With the M25 sweeping within a mile of the town, it can still claim to be the gateway to the west by road and the scenic value of the river can now compete with Windsor, Reading and even Oxford on this upper stretch of the Thames.

5. The Mills at Two Rivers and the Families That Put Staines on the Industrial Map

One of the most frequented areas of central Staines is the Two Rivers retail and leisure park on the north of the pedestrianized High Street. The name refers to the rivers Colne and Wraysbury that flow through the centre of the car park and round the site, then join together to flow into the Thames.

As if having the rivers Thames, Colne and Wraysbury was not enough, the River Ash, formerly known as Littleton Brook, also joins the River Colne here. Then there's a substantial man-made stream called Sweeps Ditch that may have been a medieval flood defence and a boundary that ultimately joins the Colne. Sweeps Ditch is underground. It has a stone near Vue cinema and its course is marked by fifteen discs set in the car park.

Here at Two Rivers, most of the artwork symbolises the meeting of these rivers. High on the wall (above Pizza Hut) on Tilly's Lane is a stainless-steel sculpture by Clare Bigger called the *Water Nymphs*. It has great significance to this watery region as there was once a widespread belief that everything in nature harboured elemental spirits, and like all nature spirits, the water spirits, nymphs or undies that were believed to frequent all bodies of water blended in with their surroundings. They had to be appeased by the correct propitiatory rights to ensure that the life-giving water continued to flow.

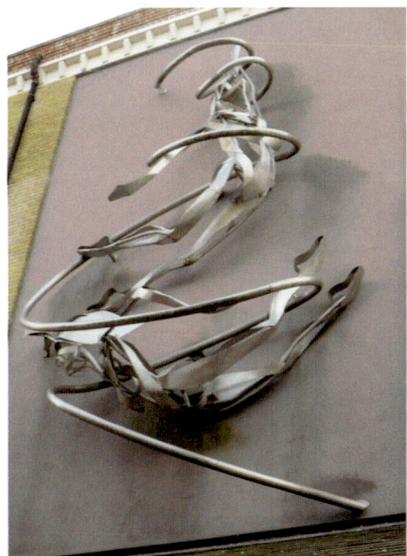

The fluid movement of the water nymphs.

48

The water nymphs here represent the prosperity the two rivers Colne and Wraysbury have given to this area. These two figurative water nymphs are coiling upwards as if caught in a vortex, their elegant twisting movement emphasised by metal swirls (800 cm high x 400 cm wide).

Another interpretation of the meeting of the two rivers Colne and Wraysbury can be found on the High Street end of Norris Road. This brick carving showing two people coming together in boats dates from 1999 and was engraved on the brickwork by sculptor Richard Kindersley. Outside the Vue cinema, another symbolic interpretation of the meeting of the rivers is shown by the *Two River Sprites* emerging from a cone of water, back to back. Halfway along Tilly Lane is a curved wall art by John MacKenna on the second floor of the building. This is another relief panel in carved brick with two ladies representing the Colne and Wraysbury rivers pouring water into Old Father Thames.

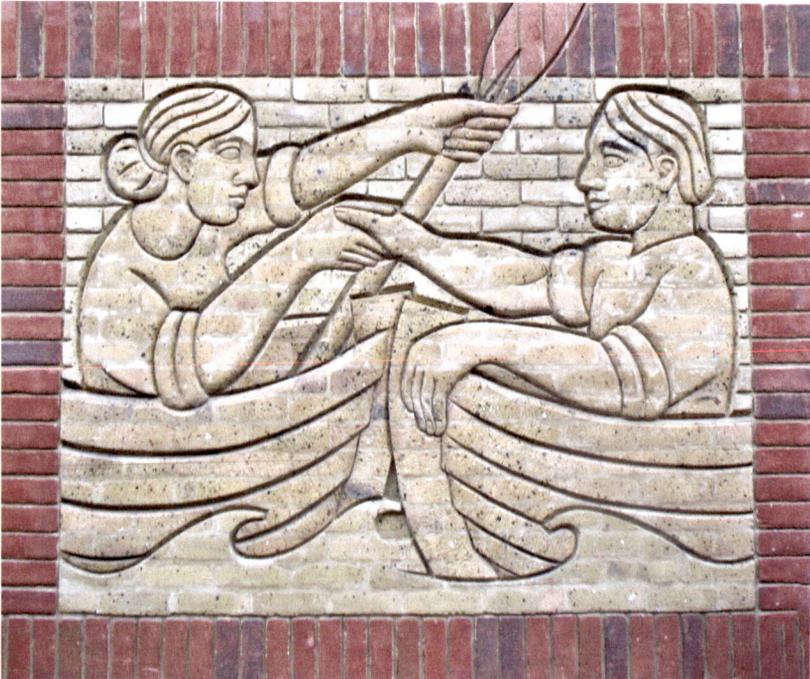

Wall art – where the two rivers meet.

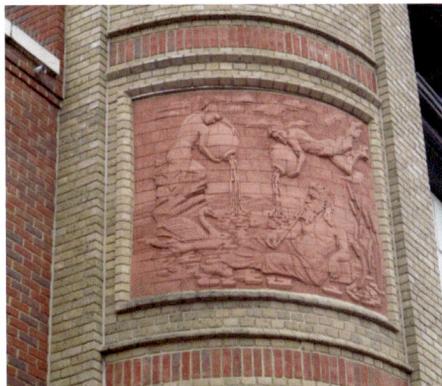

Wall art – *Old Father Thames* receives water from the Colne and Wraysbury rivers.

History of Two Rivers

Today the name is synonymous with this recreational and shopping area, but in previous centuries the river water here provided the power that drove machinery to work mills. The Domesday Book mentions six mills in Staines but later in the Middle Ages and from the sixteenth century onwards, there seems to have been two mill buildings, each consisting of several separate sets of machinery and under separate ownership. Two names that appear regularly are Hale Mill and Pound Mill.

Hale Mill was in existence from 1271 when it belonged to Westminster Abbey and was tenanted by John le Hale from whom it takes its name. After 1353 part of the mill may have been demolished to make way for the building referred to as the New Mill, first mentioned in 1388. Later it seems to have been divided among several owners and lessees. Early mills ground cereals, and in the fifteenth century, part of Hale Mill was used as a fulling mill, fulling or felting woollen cloth to make a sturdy wind and waterproof material.

Weirs and Locks

Near every mill was a weir to dam up and divert a sufficient head of water to work the mill's wheel. There was at least one weir at Staines in the Middle Ages called Savoury's Weir or Deep Weir. But the weirs had another purpose, as the word weir is derived from the Saxon word wera, meaning any structure for entrapping fish. Early weirs were hurdles of woven willow set in the river to form a fence to trap fish, but they obstruct river traffic and in 1197, it was decreed that all fish weirs on the Thames should be removed. A similar clause was written into the Magna Carta in 1215 but to no avail. Disputes were frequent, but fishing weirs, and other forms of trapping, continued through the centuries.

DID YOU KNOW
Mills and weirs have always been a significant feature of the river and there's an ancient saying 'as weary as the water of a weir'.

A primitive fishing weir on the Thames.

Milling and Brewing

The long-established trades of milling and brewing became central to the town's economy with brewers and mineral water suppliers attracted to the area by the pure water obtained by sinking 360-foot-deep artesian wells below the London clay. In the mid-seventeenth century, the Palmer family worked Pound Mill on the River Wraysbury. Pound Mill derived its name from the neighbouring parish pound, a feature of most English medieval villages to hold stray livestock until they were claimed by the owners, usually for the payment of a fine or levy.

Simon Palmer prospered in milling, chiefly as a maltster. The Palmer family became some of the most prosperous townspeople in Staines but by 1740, they had relinquished the milling business and in 1747, Pound Mill was acquired by John Finch, who probably used it to mill flour and meal. By 1755, Hale Mill had also come into his possession, together with a house, land and a meadow known as Mill Mead.

The Finch family, who were Quakers, became increasingly prosperous and in the 1820s added mustard milling to their flour milling business when they went into partnership with James Rickman. The company was known as Finch, Rickman & Co. Not only did they provide housing for their employees and managers, like the period cottages now known as Mustard Mill Cottages on Moor Lane, in 1820, Charles Finch built himself a house called Moor House adjacent to the mill. It was later occupied by his son, who in 1885 sold it to the Great Western Railway who converted it into a station (see railway section).

Pound Mill continued under the name of Mainsbridges Crushing & Grinding Mill, or simply the Old Mill, until 1916 when the building was demolished. The association with mustard continues in the name of Mustard Mill Road that circumnavigates the Two Rivers shopping centre.

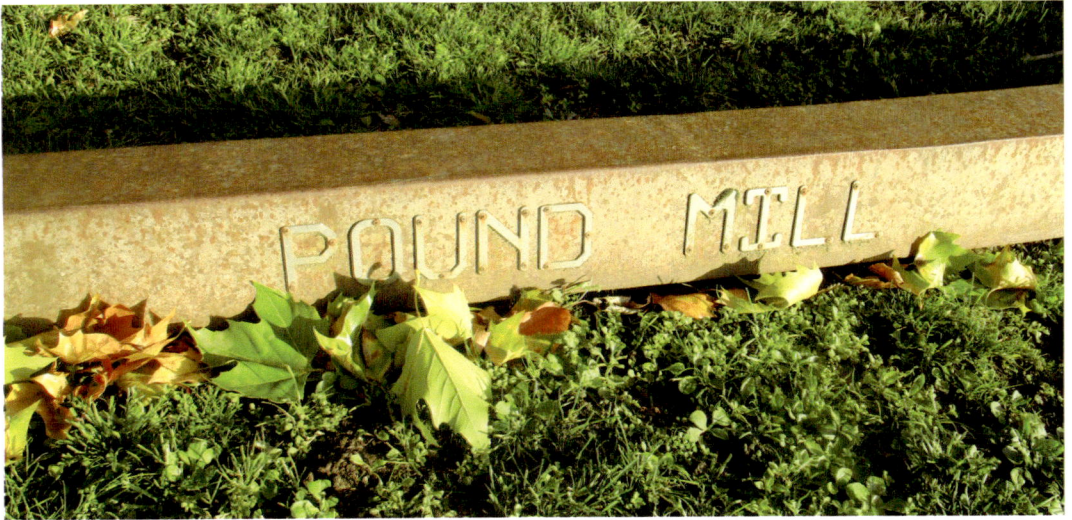

Pound Mill sign marks the former site.

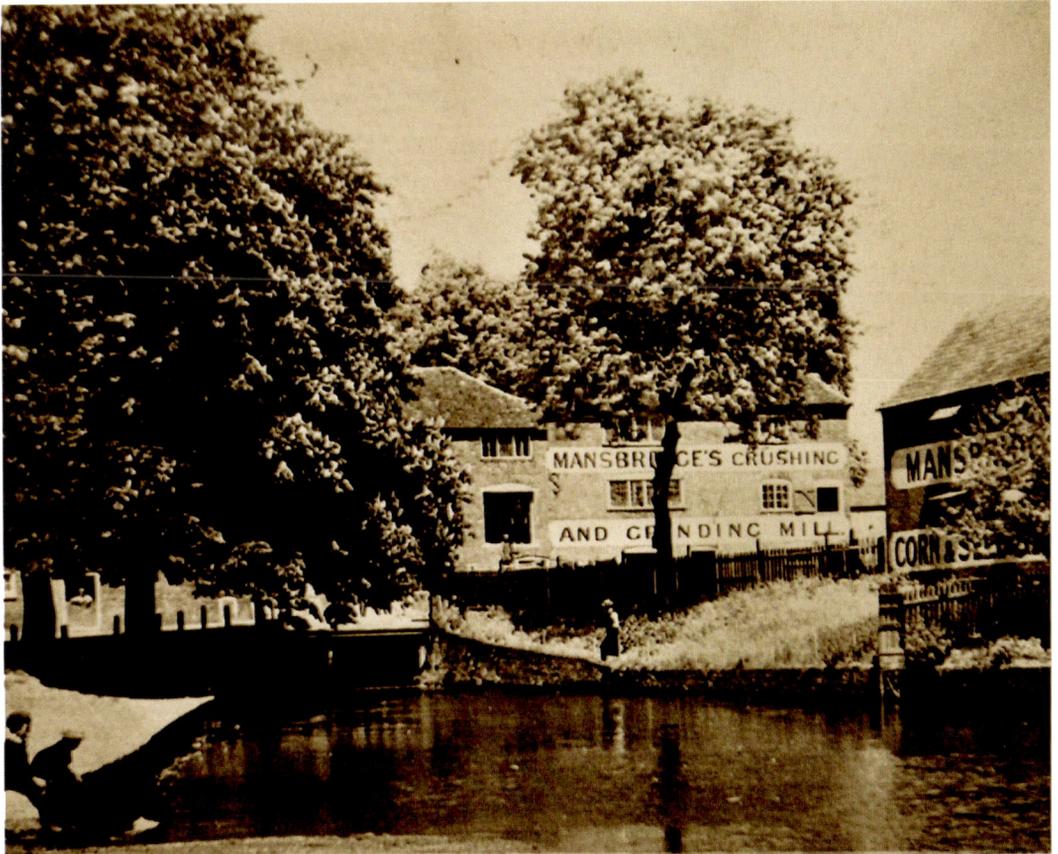

Mansbridge Crushing and Grinding Mill.

Ashby's Brewery

In 1779, the Finch family sold their leases on the mills to another Quaker, Thomas Ashby. According to legend, Thomas Ashby began by brewing beer in his garden shed at 57 Church Street and delivered casks to customers in a wheelbarrow. There was a great demand for small beer that was light and low in alcohol, as it was safer and more palatable to drink than water. To ensure the purity of water, a well was sunk to supply the brewery. Thomas Ashby was hard working and ambitious, and together with his brother Robert, who was in the milling trade in Uxbridge, they began amassing land and property in Staines.

Hops were widely cultivated in the area to provide the essential ingredient for beer, and the Grade II, nineteenth-century Malthouse on Wraysbury Road was built at the rear of No. 57 Church Street. The red-brick building retains almost all of its original external features except that there would have been a door with a hoist above to bring in the hops, malt and grain. By 1900, Ashby's brewery owned over 200 public houses within 30 miles of Staines.

The Ashby empire dominated this part of Church Street. On the left is No. 57, where the brewery and banking businesses began. Opposite is the brewery tower and the maltings.

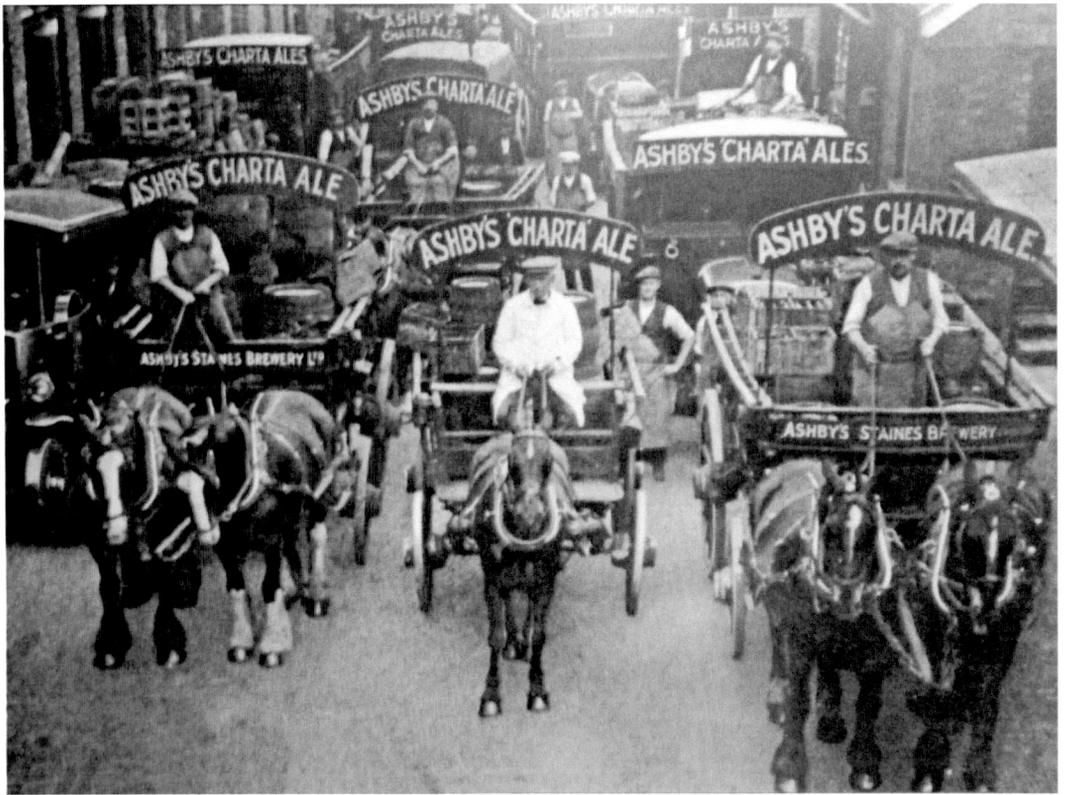

Ashby's horse-drawn delivery drays. (Courtesy of Staines museum)

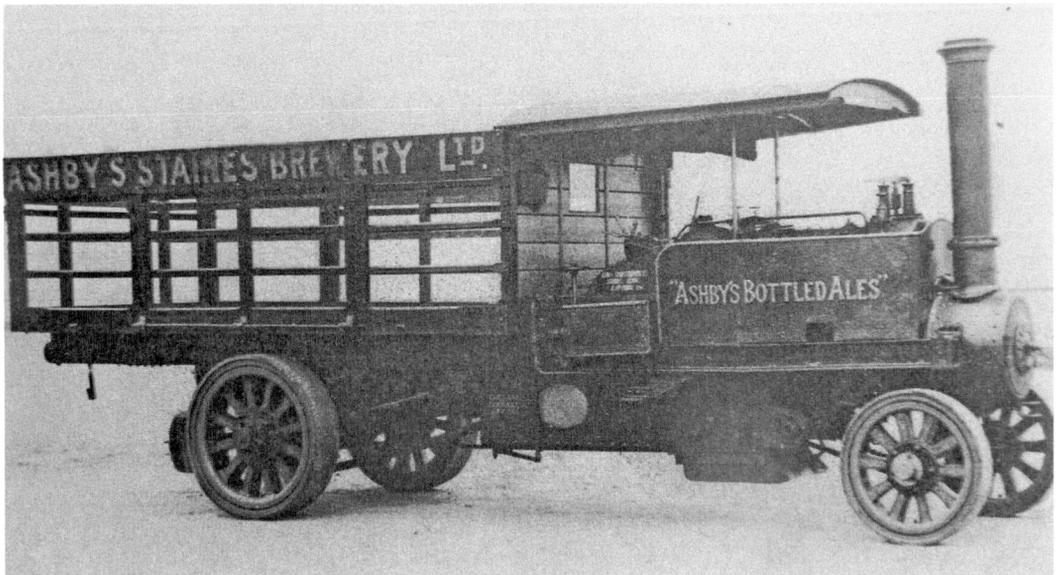

Ashby's motorised delivery vehicle.

In 1903, Ashby's took over the brewing business of Thomas Harris and the same year, the impressive crown-topped Brewery Tower was constructed. Then in 1931, the Ashby brewery business was sold to H. G. Simmonds of Reading. It continued until 1936 but brewing ceased on the site in the 1950s and bottling in the 1970s. H. G. Simmonds was in turn absorbed by the Courage Brewery Company in the 1960s. The large red building on Bridge Street is Ashby House, built in 1989 as the headquarters of Courage Brewery

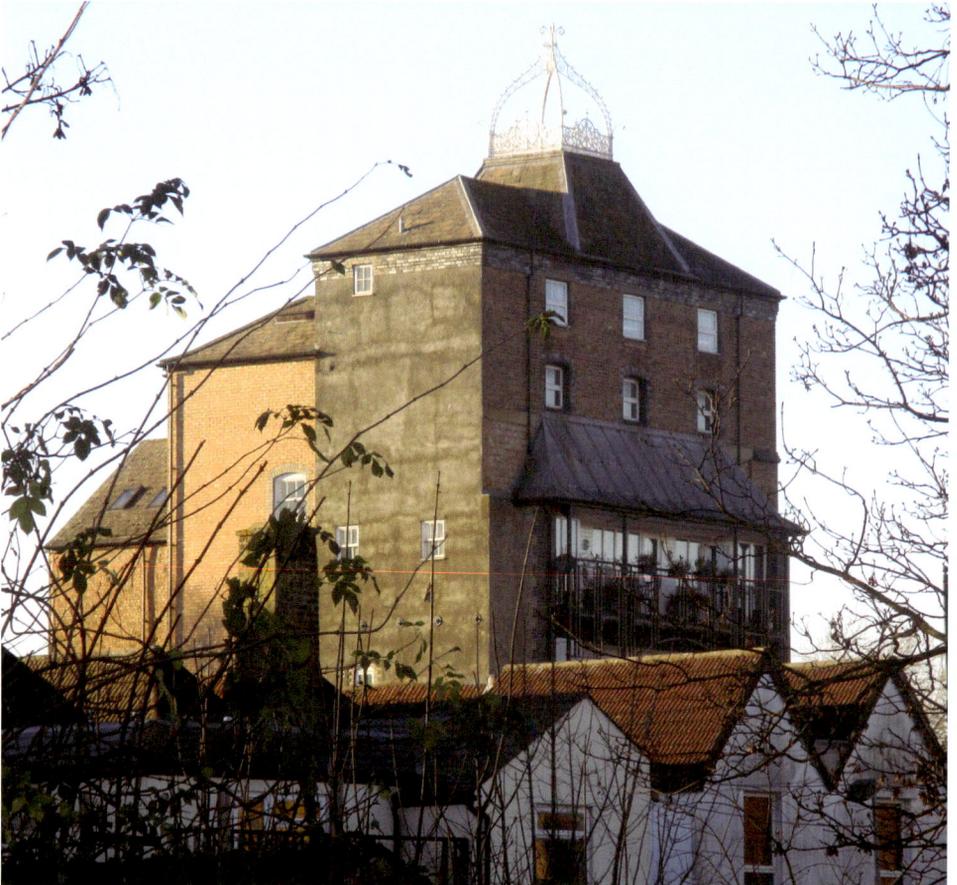

The crown-topped brewery tower dominates the skyline.

covering part of the site of the old Ashby brewery. It's now office space. The brewery tower still retains most of its original features, although in the 1960s the tower was partly converted to offices and in the early 1990s was converted to residential use.

The Ashby Family Dynasty

With his large family of nine children Thomas Ashby established a dynasty that dominated the commercial life of Staines in so many ways.

> **DID YOU KNOW**
> By 1900, there were fourteen Mrs Ashbys in Staines in a population of 4,000.

By 1796, the Ashby family business was sufficiently prosperous for it to establish a bank in a room at No. 57 Church Street, opposite the gates of Ashby's brewery. Within ten years, they had bought out their competitor, the Middlesex and Surrey Bank. Ashby bank was issuing its own banknotes until 1844.

It later moved to the High Street, occupying part of a house called Bank House, the residence of Henry Ashby. Around 1860 the bank moved temporarily into a building which had been added to Westbourne House, another Ashby residence opposite, but by 1869 was back at the new building on the site of Bank House behind which was Elmsleigh House, until 1888 the home of Morris Ashby jnr. Almost 100 years later, the site became the Elmsleigh Shopping Centre.

Ashby's bank grew until it had nine branches and thirteen sub-branches in the district. In 1903, it sold out to Barclays who continued to operate from the High Street site. It was there that during a substantial rebuild, many Roman artifacts were found.

As well as the aforementioned, there are many buildings in Staines that were connected with the influential Ashby family. Nos 57 and 59 Church Street are the original buildings where Thomas Ashby began his brewery and bank. Nos 96–104 Church Street is a three-storey yellow-brick building originally built in 1823 as two houses for the families of Charles and Thomas Ashby. They were occupied by two generations of the Ashby family, until the death of Henry Ashby in 1880 when they were sold. Now offices, the original facade has been preserved and is listed as being of historical interest.

Another Ashby residence was the wisteria-clad house on the corner of Vicarage Road and Church Street named Corner Hall, the deeds of which date back to 1620. It's reputed to have been built on the site of a leper burial ground. It was the home of Thomas and Sarah Finch who sold it to Thomas Ashby in 1772, and it then remained in the Ashby family for 120 years.

But probably their most intriguing property was Duncroft Manor House which sits between Moor Lane and Wraysbury Road.

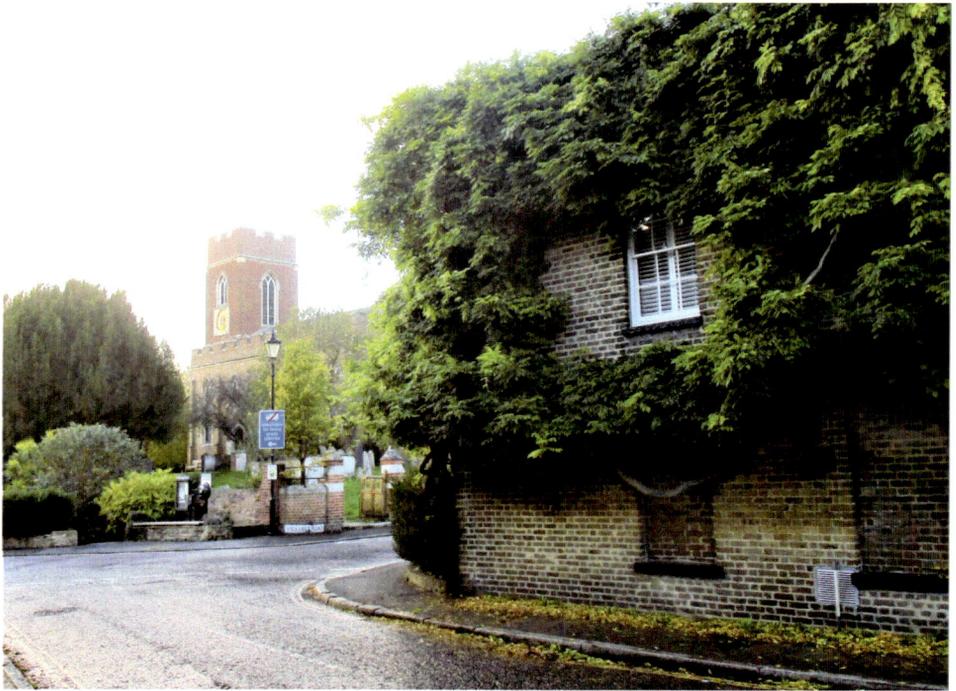

Above and Below: Corner Hall.

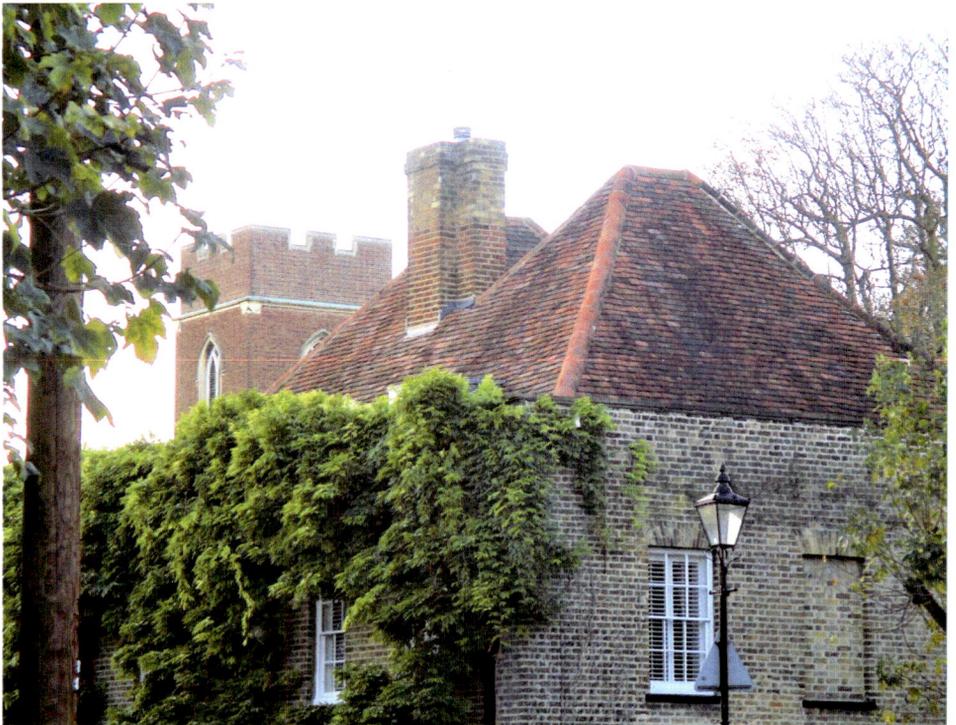

Duncroft Manor House

Duncroft Manor House already had a full history when it became home to various members of the Ashby family from 1847–92. The core dates back to 1286 and was probably a hunting lodge for royalty staying at Windsor Castle. It's said that King John stayed here and tradition has it that Duncroft played host to the group of barons who rebelled against King John in 1215 during the final days of the negotiations leading to the signing of the Magna Carta. It's recorded that 'in the plain called Runnymede between Windsor and Stanes (sic) on the 15th day of June in the seventeenth year of our reign (1215) the Magna Carta was signed'.

The present building, with its Jacobean and Georgian architecture, was originally built in 1631 and extended in 1798. It became the home of the Hon. and Reverend Gerald Valerian Wellesley and his wife the Hon. Magdalen 'Lily' Montagu. While serving as vicar of St Mary's Church, Staines, he became the Dean of Windsor and domestic chaplain to Queen Victoria, playing a major advisory role in the royal family's personal affairs. He was one of the Queen's chief confidants and often served as an intermediary in her problems and conflicts. He was also a friend of William Gladstone, the Prime Minister. When he died in 1882, he was buried in St George's Chapel, Windsor, and his widow was appointed Woman of the Bedchamber to Queen Victoria.

Duncroft was much altered and enlarged in the eighteenth and nineteenth centuries. From 1847–92, it was owned by the Ashby brewing and banking family, and from this era we have a ghost story. This unsettled spirit of Duncroft House was a black boy who

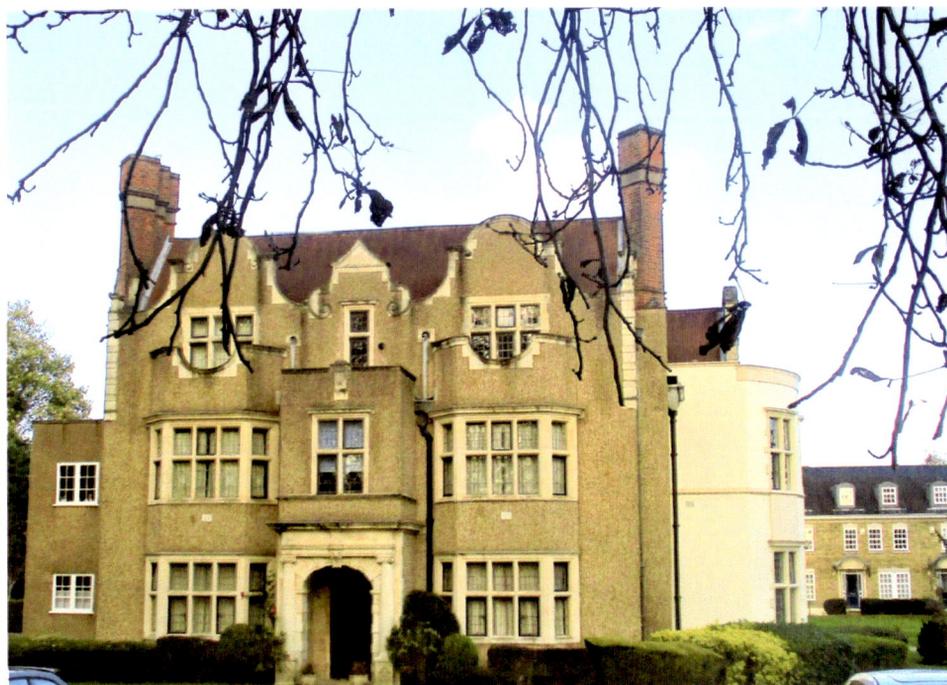

Duncroft House.

had been murdered by a cook, and to rid the house of this malevolent spirit, a local priest was called in. After attempting to exorcize the spirit, the reverend gentleman came to the conclusion that it would not leave unless it had somewhere else to go. No doubt after a lot of wrangling, a small alley off the High Street was named Black Boy Lane, and the spirit was instructed to relocate. This seemed to have had the desired effect even though the alley disappeared in the nineteenth-century redevelopment of the area.

After the Second World War, the Duncroft Approved School was established here. In the 1960s land was sold to allow Wraysbury Road to link up with Moor Lane and Hale Street. In 1982, the house was again extended when the west wing was built. The school, which was run by the National Association for Mental Health (NAMH, known as Mind since 1972), could accommodate thirty-four senior girls aged from fifteen to seventeen who were classed as intelligent but emotionally disturbed. Sadly, it gained notoriety when it was linked to the paedophile DJ Jimmy Savile, who allegedly carried out at least forty-six sexual offences at Duncroft School which he visited regularly between 1974 and 1979. Investigations found he stayed in a flat on the top floor and had unrestricted and unsupervised access to pupils. He died in October 2011.

In the late twentieth century, Duncroft was purchased by developers Nicholas King Homes, and was converted into thirteen one- and two-bedroomed apartments.

6. Railways, Lino, Candles and Lagonda

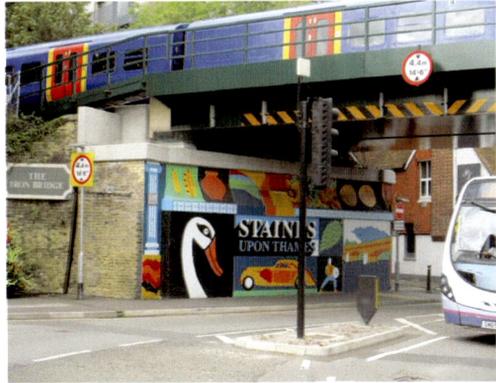

The Iron Bridge with a train passing over and the 2023 mural by Nathan Evans.

In the first half of the nineteenth century, the main industries of the town were Ashby's brewery, the Patent Wood or Fibrous Slab Company making a versatile product similar to papier-mâché, the large flour and mustard mills, Hodders who made Windsor Sauce and a number of coachbuilders. Staines was still a major coaching route and river port, offering hospitality and warehousing. In 1830, 3,000 barges passed through Staines.

But the nineteenth century was a time of major change with the arrival of the railways in 1848 providing a swift and efficient service to Waterloo and outwards to Windsor.

> DID YOU KNOW
> There was a railway station called Staines Halt in the High Street between Mill Mead and Factory Path serving a loop line provided by the London and South Western Railway largely for the benefit of Queen Victoria. With covered platforms on the embankment by the Iron Bridge, when the queen was commuting between Windsor Castle and Osborne in the Isle of Wight, she was able to change trains and lines here. The station fell out of use and was demolished in 1914 (some say 1920).

This announced the end of the coaching age and a change in status for Staines. The number of coaches dwindled until fewer than half a dozen were passing through the town every day. No longer a major stop on the road to and from London, the inns were no longer needed, the hospitality industry suffered and many locals lost their means

of employment. But the railway provided an invaluable service running through the industrial heartland of Staines, attracting new industries and helping many existing industries grow.

In 1856, the Staines & West Drayton Railway Co. was formed to provide a second line into the town, linking Staines to the Great Western Railway line. It was during this period that the town grew rapidly, industry flourished and as new industries became established north of the High Street, the streets around it were soon built up with small terraced houses for the workers and more shops to cater for the increasing population. The railway line virtually cut the High Street into two halves as the Iron Bridge carried the London and South Western Railway line to Windsor over the High Street.

DID YOU KNOW
The original Iron Bridge had a curved arch and had to be rebuilt in the twentieth century because double-decker buses had to drive down the centre of the road to get under it.

Staines – the riverside resort.

As this greeting card shows, Staines had some picturesque riverside properties.

Houses were built along Gresham Road where the railway station was built and spread south into the hamlet of Knowle Green. Villas and industrial housing joined the few cottages and farms which had been there before. As well as becoming a commuter town, crowds of day-trippers took advantage of the excursion fares from London, and Staines became a popular river resort for all social classes. The river took on a new recreational role, offering rowing boats and punts.

In 1885, the Great Western Railway bought Moor House, the Georgian house originally built in 1820 for Charles Finch, and later occupied by his son, owners of the adjacent Pound Mill. The front gardens of Moor House (now the back of the building) provided space to build tracks and a platform, and this terminus station opened on 2 November 1885. Eighty years after opening, the line closed to passengers on 29 March 1965 with the last working train running into Staines West in January 1981.

Now converted to offices, the old station house remains and the station wall still bears the sign 'Staines West'. A railway buffer and part of the platform still exists and a section of the rail is embedded in the floor of the car park. Two of the cast-iron supports for the canopy have been retained and now support the lights of the car park.

Mustard Mill Cottages look straight across to the former Staines West station where on a lawn in front of the building is an unusual sculpture representing the history of the site with the theme of milling and rail transport. Sculptor John Atkin was commissioned in 2006 to produce this industrial piece based on railway lines and cogs made from corten steel and stainless steel. Just north of the sculpture and to the right is a footbridge over the River Wraysbury. From the bridge, look down and you will see a small weir on the site of the waterwheel which provided the power for Pound Mill from the seventeenth century until it ceased working in 1912.

DID YOU KNOW
During this period the town became known as Smelly Staines due to the pungent aroma coming from the mustard factory, the breweries and the candle factory.

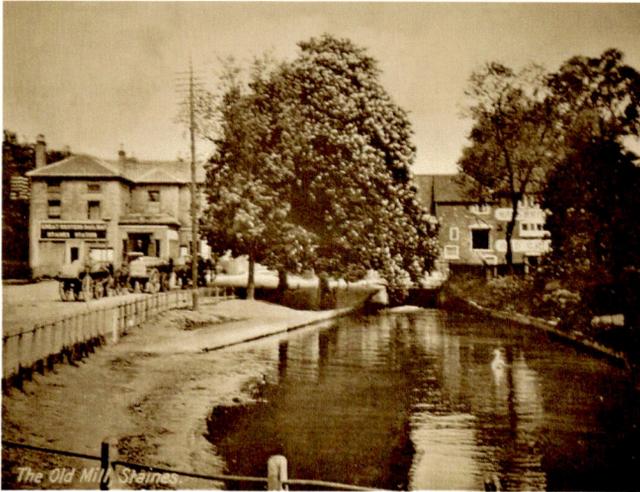

Moor House, the former home of Charles Flinch and built next to his mill, became the Staines & West Drayton railway station.

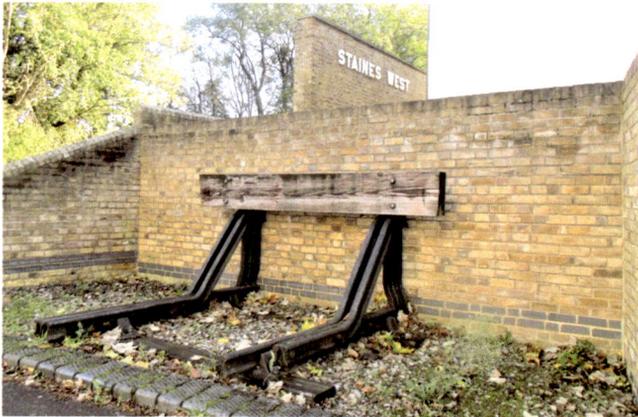

A former railway buffer and the sign Staines West.

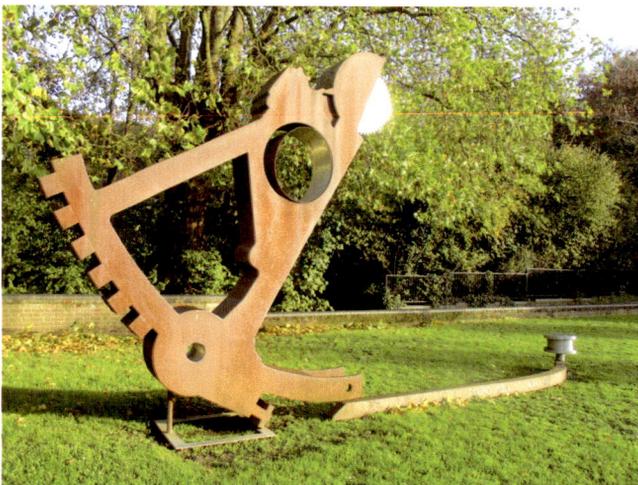

Pound Mill sculpture.

Lino

In 1864, a newcomer arrived that really put Staines on the industrial map. Frederick Walton's keen mind worked on several clever ideas and inventions but in 1855 came his eureka moment. He noticed a rubbery, flexible skin of solidified linseed oil had formed on a can of oil-based paint. He mixed it with cork chippings, accelerated the oxidation process by heating it with lead acetate and zinc sulphate, and when he'd perfected the technique, he took out a patent. Backed with burlap or canvas, it was a perfect floor covering. He called it Linoleum, which he derived from the Latin words 'linum' (flax) and 'oleum' (oil).

The weir that worked the lino mill.

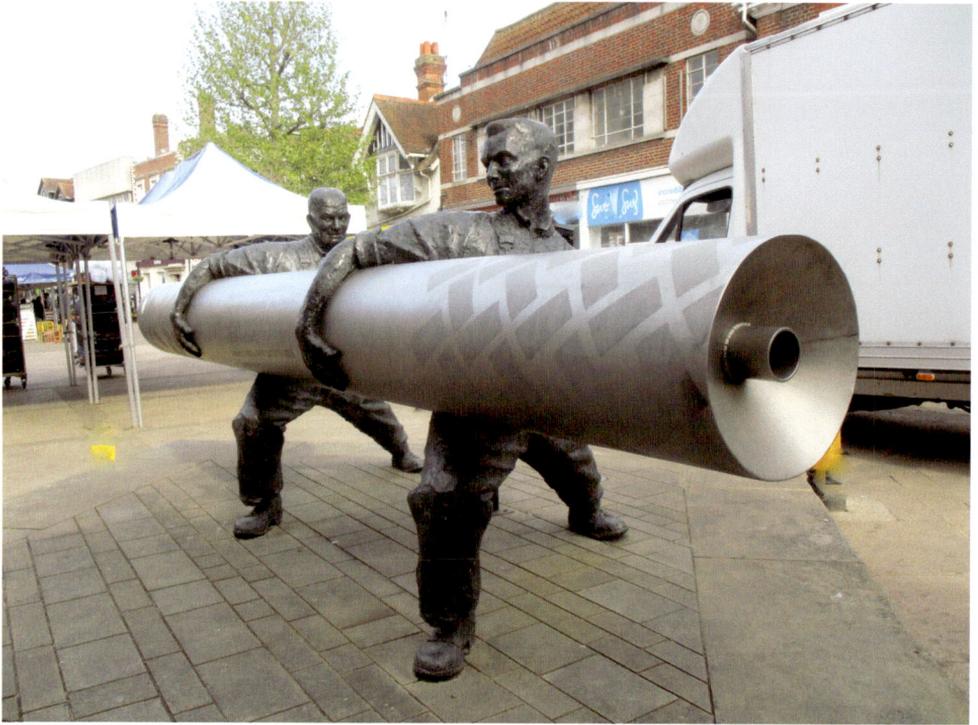

The statue in the High Street with the title *Release Every Pattern* by David Annand.

He took a lease on Hale Mill, alongside the River Colne in the heart of Staines, and here in 1864 he formed the Linoleum Manufacturing Company. Presenting a cheaper, durable alternative to the more expensive materials, this relatively simple flooring was produced in a variety of colours and patterns. Shortened to Lino, it's considered to be the first product name to become a generic term.

Linoleum was an excellent, inexpensive floor covering for high-use areas, and was versatile in both design and function. By 1869 the factory in Staines was exporting to Europe and the United States of America. It was used extensively on ships including the fated *Titanic*. The company continued to grow and by 1930, the factory site covered a vast area of 45 acres that lay between Staines High Street and the railway line. In 1876, around 220 people were employed here and this figure rose to 3,000 in 1930, making the Linoleum Manufacturing Company the major industry in Staines and the main source of employment in the area.

It became a global success on an unheard-of scale for the time. The American market was so huge that Frederick Walton, in partnership with Joseph Wild, bought a 300-acre plot on the west shore of Staten Island, a borough of New York City, constructed a large factory with docking facilities and in 1872, opened the American Linoleum Manufacturing Company. The company's town was named Linoleumville, but in 1930 when the company moved to Philadelphia, the name was changed to Travis after Colonel Jacob Travis whose family had previously owned the land.

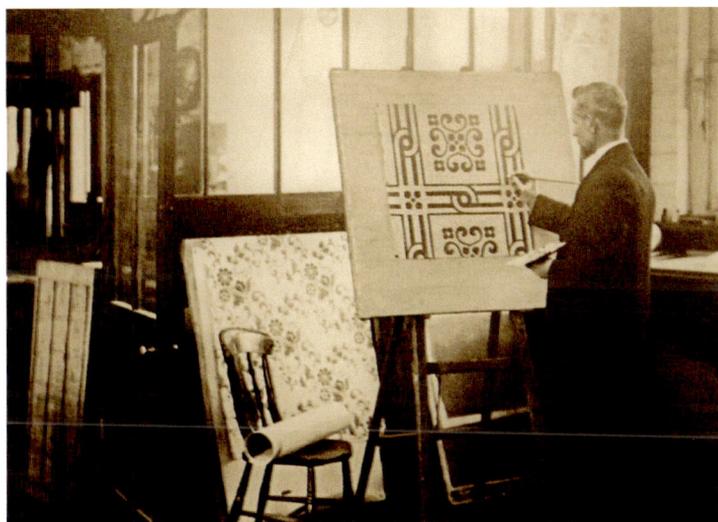

The workshop producing lino.

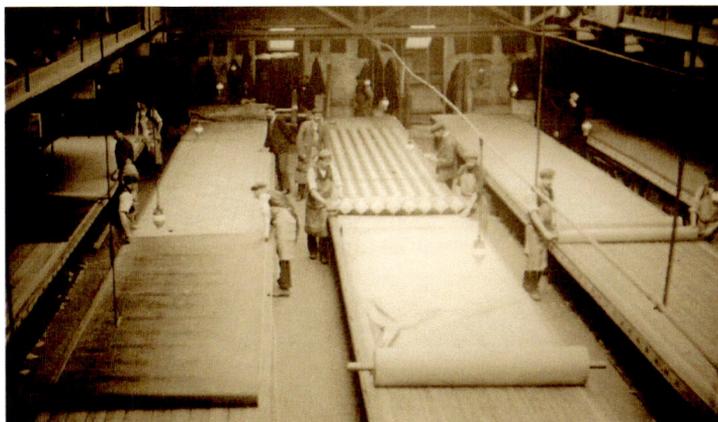

The design office.

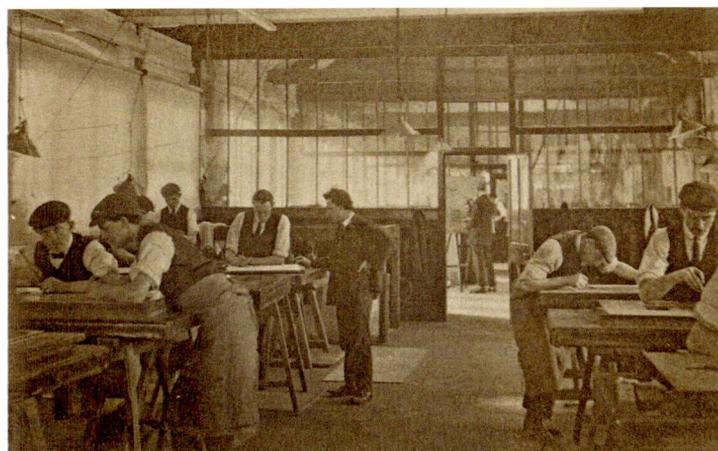

Draughtsmen at work.

Candle Factory

A former farm that covered a considerable area of land along the south side of the High Street between Kingston Road and the Iron Bridge was the site of a candle factory and shop selling candles, oil, soap, soda and salt. Inexpensive candles were made of tallow, an animal fat that when rendered down gave the area a most unpleasant smell. At the beginning of the twentieth century the proprietor was Mr W. G. Smith, and on 8 April 1924, the candle factory caught fire. The *Middlesex Chronicle* described it as the most disastrous fire Staines had seen for many years. The fire broke out in the taper room where over 200 barrels of wax, candles, polishes and other combustible materials were stored. The reporter said, 'a roaring mass of flames leapt high in the air, miniature rivers of wax flowed into the street and were carried along by the water from the firemen's hoses to a depth of several inches in the gutters, choking the drains and settling on the roadside and paths. In the factory, the wax was as much as a foot deep (30cm) in places.'

Policemen and firefighters spent three hours and used 400 gallons of water to fight the blaze, their task being exacerbated because they had to wade through knee-high molten wax which blocked the drains – labourers had to be brought in to hack through the wax as it set hard. The building was a ruin and clearing up was a difficult task. Riverlets of molten wax had set hard in the drains and could not be moved. Some was only dislodged forty years later when roadworks were taking place. The land was sold to Crimbles, motor dealers, who built their workshops there, and within a few years the site was redeveloped with the long row of shops known as Central Parade and a new office block, Atlantic House.

DID YOU KNOW
Tommy Crimble, who started one of the first Ford car dealerships in the country in Staines, was also chief of the old Staines voluntary fire brigade. He was responsible for converting its horse-drawn fire engines to motor vehicles.

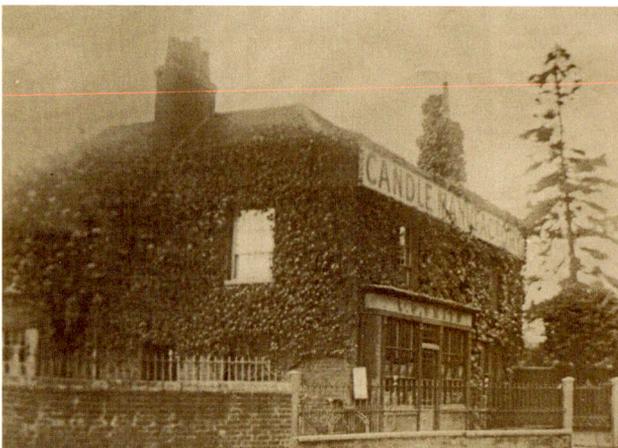

Smith's shop and candle factory.

The Lagonda Motor Company

In 1906, the Lagonda Motor Cycle Company was founded in Staines, by American Wilbur Gunn who named the company after Lagonda Creek near Springfield, Ohio, the town of his birth. He began building motorcycles in the garden of his house at 6 Thorpe Road, Egham. With reasonable success, including a win on the 1905 London–Edinburgh trial, in 1907 he launched his first car, the 20 hp, 6-cylinder Torpedo, which won the Moscow–St Petersburg trial of 1910. This success enabled him to establish a factory on the site where Sainsbury's supermarket now stands. In the pre-war period Lagonda also made an advanced small car, then during the First World War, they produced shells, periscopes and fuses, flame-carriers and gun-carriages. Following Wilbur Gunn's death in 1920, Lagonda's success continued, achieving a controversial Le Mans victory in 1935, but that same year a receiver was called in. The company was bought by Alan P. Good, who just outbid Rolls-Royce. Good persuaded W. O. Bentley to leave Rolls-Royce and join Lagonda as designer along with many of his racing department staff.

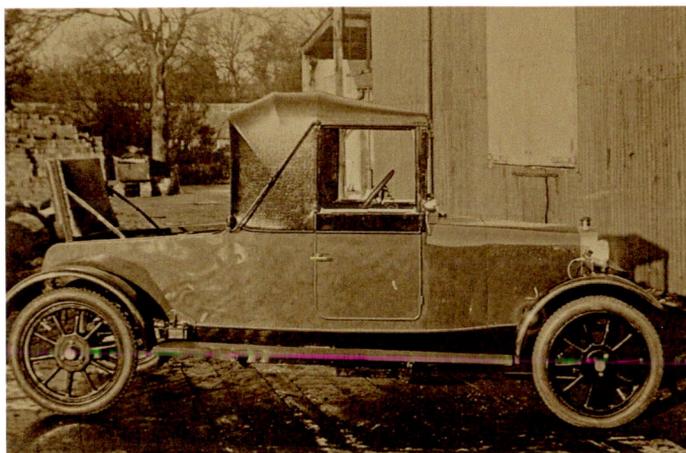

Right: Early Lagonda.

Below: the site of the factory.

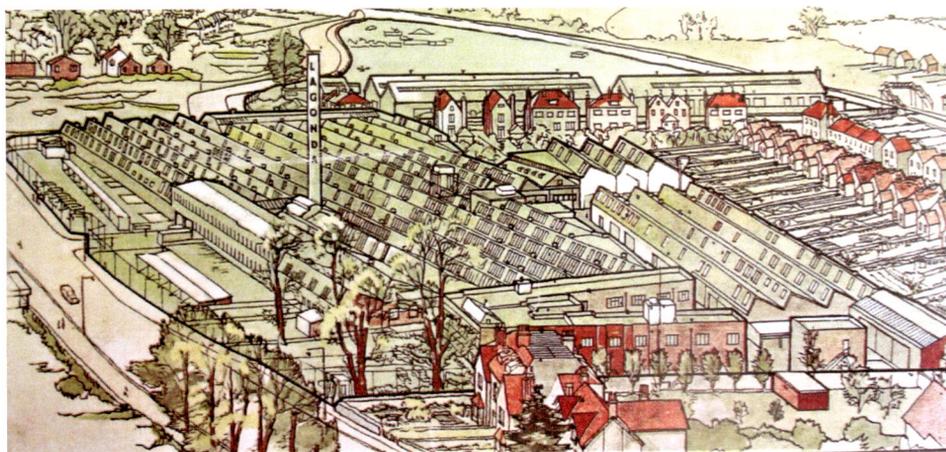

As in 1914/18, between 1939/45, the whole of the firm's resources changed over to the
production of munitions for war, components and equipment for fighter and bomber
aircraft. The company was taken over by Aston Martin in 1947 and moved just up the
road to Feltham, while the old Staines works at Egham Hythe passed to Petters Limited.
Lagonda still has its own niche with luxurious and truly versatile products suitable for
both existing and emerging markets, and when asked to suggest items that depicted
Staines for the Swan Arch leading into the riverside gardens, the option of a Lagonda in
flat relief was a great choice.

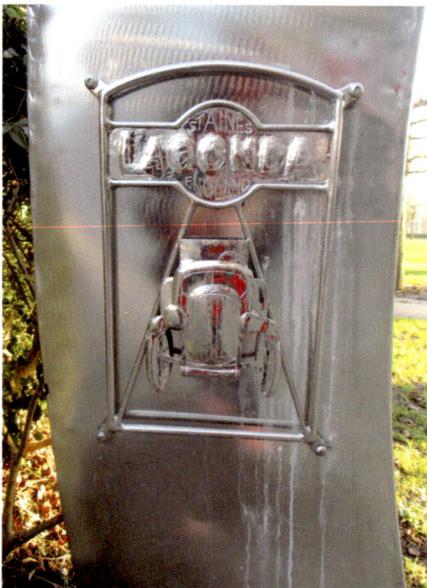

Image of a Lagonda on the Swan Arch.

The End of the Lino Manufacturing Company

In war years all available factory space was requisitioned, and like Lagonda, the Lino factory was used for the manufacture of torpedoes and air blast gyroscopes, then after the war the Linoleum Manufacturing Company continued in production. In 1956, the factory was producing around 3,200 sq. yds of linoleum each week, but it was facing stiff competition from other floor coverings and closed in 1969.

DID YOU KNOW
In March 1969, the empty lino factory was the venue for a Virgin Records *Supershow*, a music documentary film featuring the cream of contemporary rock, blues, and jazz including Led Zeppelin and Eric Clapton. The whole project was planned with great secrecy and filming took place over two days at a reputed cost of £100 per minute. The film received a limited run in London in November 1969, and later emerged as an official video release by Virgin Vision in 1986.

Most of the factory buildings were demolished in 1973 and the land sold. A large part became the Central Trading Estate and the remainder, the Moormede housing development. In the late 1990s, the trading estate closed and the site was obtained by MEPC and Westfields who were already operating shopping centres across Australia and the United States. In 1999, Two Rivers opened with a wide range of shops and leisure facilities, and in 2002 Warner Bros opened Vue, a £16 million cinema, in the Two Rivers Centre. With seating for 2,219, ten huge screens, and the latest in Dolby Digital surround sound technology, it provides a fantastic and memorable cinematic experience.

Cinemas in Staines

How different things where when Staines had its first cinema, The Palace. In 1874, Staines benefactor Margaret Pope opened a school in the centre of a row of shops that once occupied the north side of Thames Street. It closed in 1903 when the Kingston Road school opened, and after being revamped and enlarged by Bill Hedges who owned the sweet shop next door, it opened as the town's first cinema, The Palace. Mr Herridge, who had a nearby photographic shop/studio, operated the flickering pictures that were silent but accompanied by a tinkling piano that built up the tension or encouraged the tears. Performances continued daily from 3.00 p.m.–10.30 p.m. but times were changing and around 1914, the cinema closed. Despite its unusual façade with its octagonal pointed tower which gave it a very distinctive look, in 1973 members of the former Staines Council decided to demolish it to accommodate the South Street one-way system and Tothill multi-storey car park. Despite a campaign to save it to be used as a community centre or museum, the decision was passed fifteen to six. Ironically, the present Staines museum and library complex is on the almost identical site.

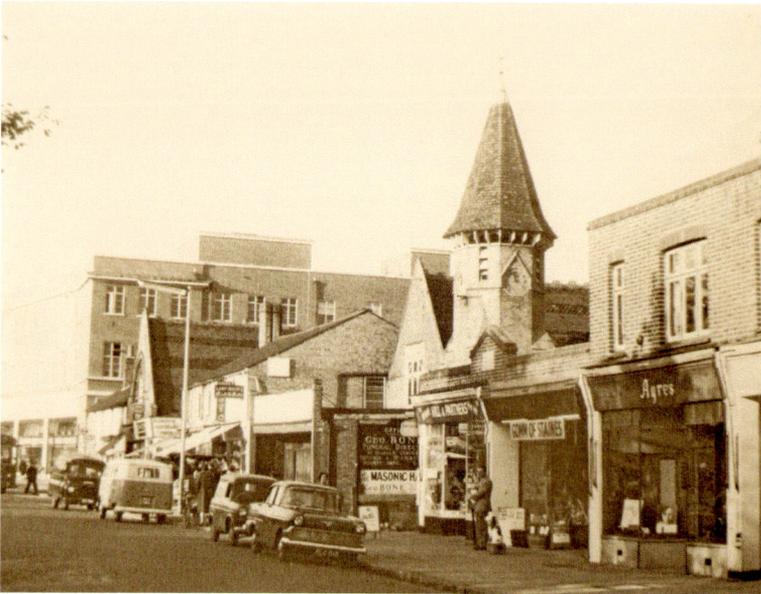

Margaret Pope School on Thames Street became Staines' first cinema.

The Palace theatre.

Staines acquired its first purpose-built cinema, called The Empire Cinema but known meaningfully as the 'fleapit', in 1914. The Empire was built beside Factory Path at the Iron Bridge end of the High Street, not an ideal site as due to its close proximity to the railway line, the screen shuddered when trains rattled by. It operated for sixteen years, closing in the late 1930s when it was superseded by The Majestic, also on the eastern section of the High Street, but on the opposite side of the Iron Bridge. The Majestic stood almost opposite Station Path on the former site of a lavish house in huge gardens, called Fairfield House, named by Dr Walter Satchell and his American wife after her hometown in Connecticut.

In the early 1920s the house was briefly used as a convent. It then became a restaurant/ hotel with several name changes: the Silver Teapot, Marmadukes, then The Sevens Hotel in honour of Edward VII who spent a considerable amount of time in and around Staines.

The building was pulled down and after an intense eighth-month build, the Majestic Theatre was erected in its place. The Majestic opened its doors on 11 December 1929, the opening ceremony performed by Commander Sir Edward Nicholl of Littleton Park, Shepperton, the birthplace of Shepperton studio. As its name implies, it was a majestically ornate cinema with a Venetian scheme of decoration and large auditorium. The Majestic flourished throughout the heyday of the cinema. It seated over 1,500 and its grand splendour rivalled the large cinemas of the West End. It had a restaurant, a dance hall and hosted many popular live acts of the day, transforming the nightlife in the town.

The Majestic closed in May 1961. The building was demolished to make way for a new parade of shops with the old name being given to Majestic House office block behind them. Fairfield Avenue was built in the orchards and gardens to the east of the house. The Majestic House offices and the shops including the old post office were demolished in 2008. The site is now renamed London Square.

The next cinema was The Regal operated by Associated British Cinema (ABC). It stood on the site of the former Bridge House built c. 1832 that occupied the prime position between Staines Bridge and the Colne Bridge, with gardens backing onto the Thames. In 1898, Bridge House had been bought by Tom Taylor, who built a boathouse on part of the land and established a successful boatyard that continued to trade successfully for decades. Taylor converted Bridge House into a grand hotel named the Bridge House Hotel. It was the one of the first buildings in Staines to have electricity. For three decades the hotel was the main social hub of the town with open-air dances and concerts taking place in the sprawling riverside gardens. But the hotel ran into financial difficulties, closed in 1937 and was demolished the following year.

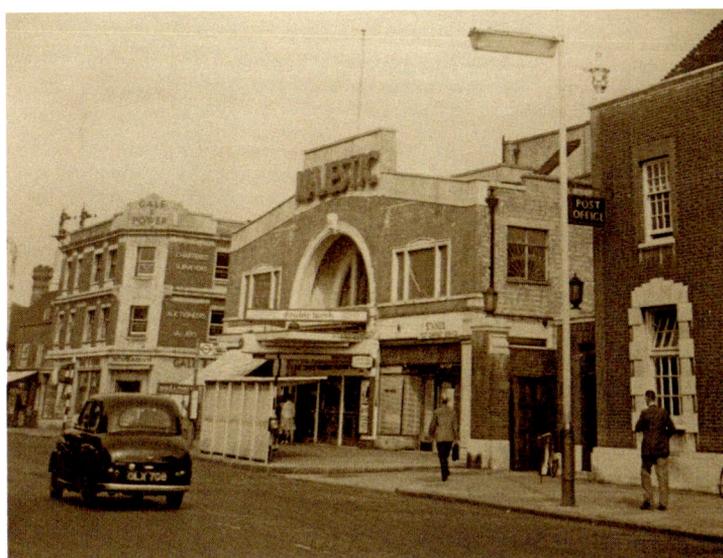

The Majestic, on the right, is the old Post Office.

The site was bought by Associated British Cinema (ABC) and opened as The Regal on 20 February 1939. It underwent several changes due to various takeovers throughout the 1970s, then with plans for a new multiplex to be built in the town, the ABC finally closed on 14 January 2001 and was demolished in August that same year. A residential apartment block with food and drink outlets on the ground floor is now on the site, and Vue, the state-of-the-art multiplex cinema, is now situated at Two Rivers.

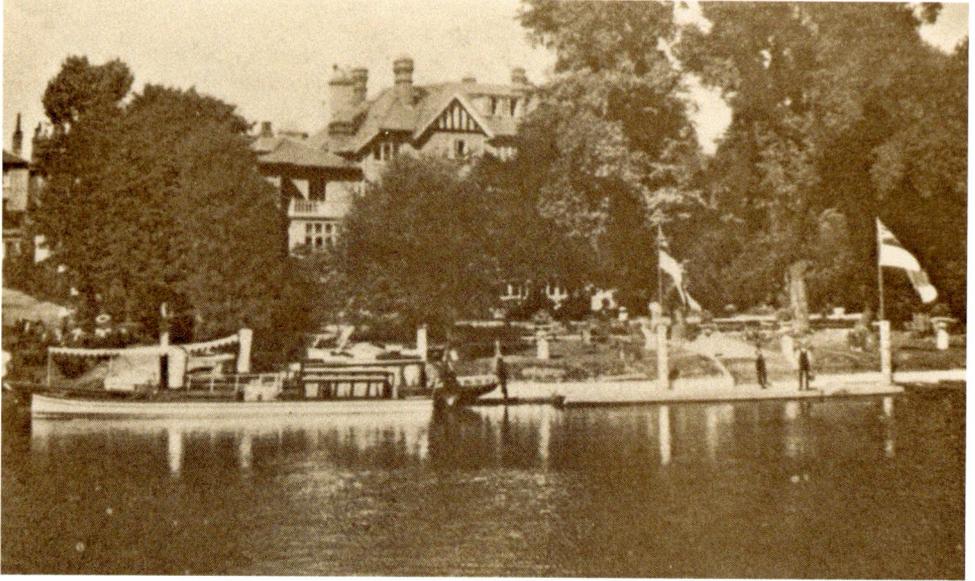

The Bridge House Hotel embraced the river views.

The ill-sited ABC did not embrace the river views.

7. Staines to Laleham along the Thames Path

Staines and Laleham are linked by the River Thames and one of the earliest roads in the parish, but the two centres keep their individuality. We will take the Thames Path, a long-distance National Trail opened in 1996 which follows the River Thames for 184 miles, from its source near Kemble in the Cotswolds to the Thames Barrier in Greenwich.

Swans along the River

Joining the route at Staines village that clusters around the church of St Mary, we walk south/east.

The swan is the symbol of Staines and can be found in many guises around the area. Before reaching the bridge we pass Thames side brewery, Staines' latest micro-brewery, who produce a signature ale named White Swan.

Staines village sign showing the significance of the swan.

DID YOU KNOW
For every pint of White Swan sold, the brewery makes a contribution to the Swan Sanctuary in Shepperton, a wildlife hospital that provides treatment, care and rehabilitation to swans and wildfowl in the UK.

Two swans are in the town's arms officially granted on 4 June 1951. The central feature is a representation of Staines Bridge, on white and blue waves that represent the Thames. Below on either side of the London Stone are two seaxes, an Old English word for knife from the arms of the Middlesex County Council, in whose area the district was originally situated. The motto *'AD PONTES PROSPICIMUS'* – *At the bridges we look forward* – refers to the importance of Staines Bridge in Roman times.

The Swan Hotel seen through one of the bridge's arches.

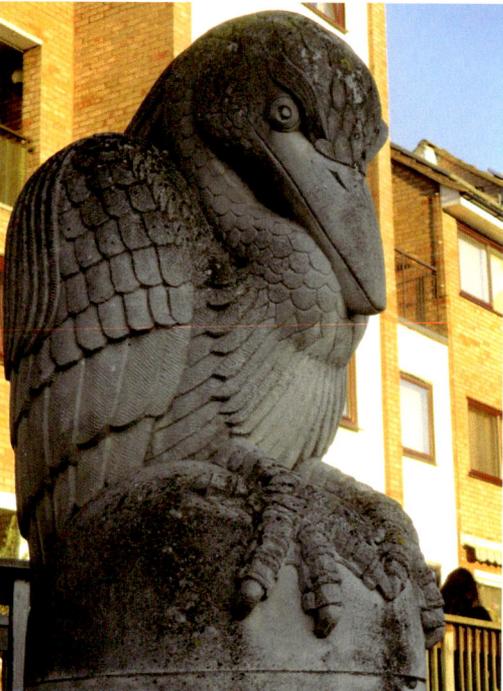

The river guardian.

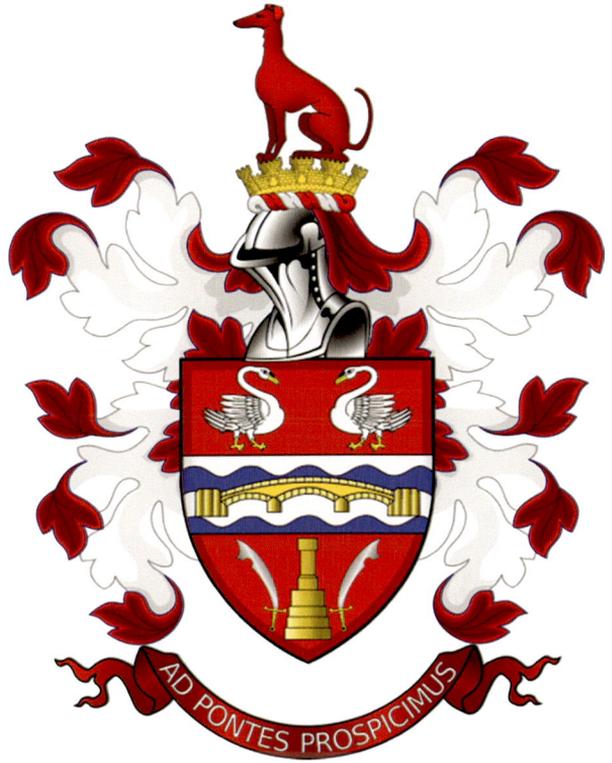

The town's arms.

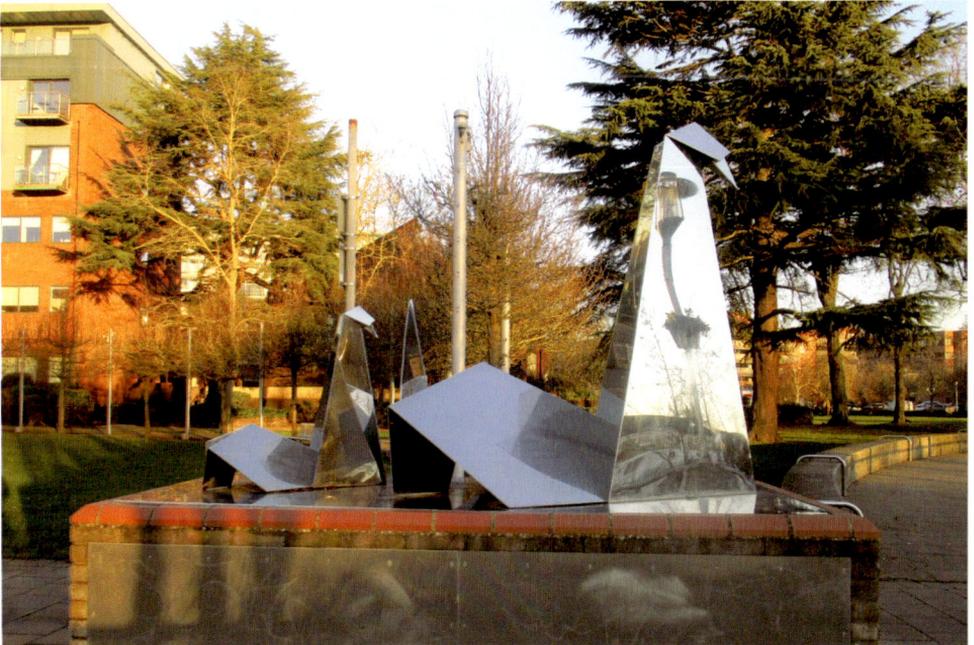

The origami swans.

Sitting adjacent to Staines Bridge but across on the opposite bank of the river is the Swan Hotel. This sixteenth-century inn is a glorious place to relax on the river and can claim to have hosted the famous diarist Samuel Pepys, who was a frequent visitor to the Swan Upping lunches (see Swan Upping).

Cross the bridge and pass over the footbridge where the River Colne joins the Thames. Here we find the river guardian, a stylised stone representation of a heron by Simon Buchanan.

As we proceed along the Thames Path, we pass behind the Town Hall and enter the riverside gardens where we can enjoy the multiple statuary. Here is the replica London Stone, *The Five Swimmers* sculpture by David Wynne and *The Origami Swans* by Tom Brown. This mother swan and two cygnets is made from folded polished stainless steel in the style of origami.

There are two stainless-steel Swan Arches made by Anthony and Simon Robinson marking entrances to the riverside gardens from Thames Street. The motifs on the legs were designed by pupils of a local junior school, and each leg depicts images of the town. Both arches have a single swan in flight at the top.

Above left: Swan Arch.

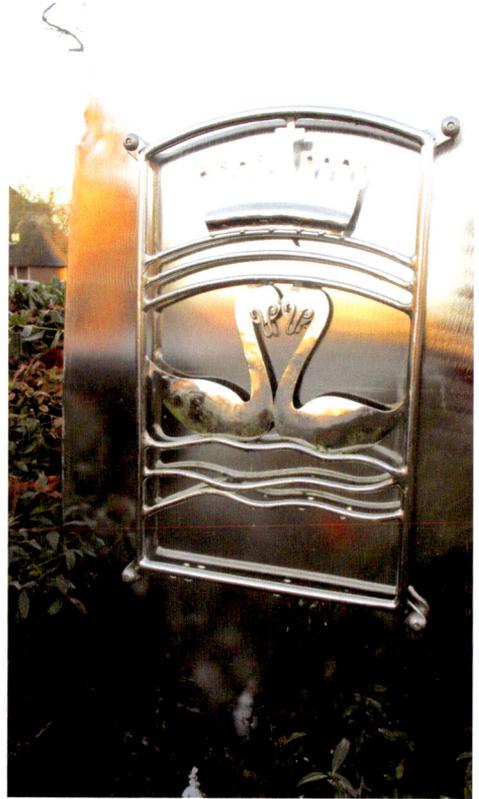

Above right: Swans on the arch.

The carved swan on the building represents the swan brewery.

There are other swan themes scattered around the town. Almost at the end of Kingston Road where it meets London Road is a nineteenth-century building that was the Staines depot of Stansfield & Co. of the Swan Brewery at Fulham. The image of the swan on the top middle of the building represents its original owners.

There is Cygnet House, a nineteenth-century, Grade II listed white building behind the war memorial in the centre of Staines, and if you stand at the entrance to Goring Place on Church Street, ahead of you is the side of the Vue cinema on which is an engraving depicting a swan going into flight and 'Two Rivers'.

DID YOU KNOW
The riverside gardens are a popular place to sit and enjoy the river and perhaps feed the swans. Traditionally people toss bread but that can cause dietary problems, so instead, feed grain, such as wheat, and vegetable matter, especially lettuce and potatoes.

Swan Upping

The ancient Swan Upping Ceremony has taken place on the Thames annually since the twelfth century. This began when all unmarked mute swans on certain stretches of the River Thames and its surrounding tributaries were claimed by the Crown in order to ensure an ample supply of meat for royal banquets and feasts. Swans have always retained the image of being a luxury food associated with the royal table, and it was considered treason for peasants to kill or eat swans. Swans are still a protected species, so you're not likely to find swan breasts in the freezer section at Waitrose.

Swan upping – a swan census held annually since the twelfth century.

By prerogative right, the Crown still enjoys ownership of all unmarked mute swans but two livery companies of the City of London – the Vinters Company and the Dyers' Company – also retain ownership, so a certain number of swans could be culled for their company's feasts too.

To identify their swans, they developed the Swan Upping Ceremony. They record the number and health of birds on the river and mark the new cygnets to show who owns them. The practice takes place on this stretch of the Thames in the third week of July every year over five days. Traveling with banners flying, the Royal Swan Uppers, who wear the scarlet uniform of the Crown, along with the uniformed men of the companies of Vintners and Dyers, travel in a flotilla of traditional rowing skiffs. It's customary for the flotilla to stop at the sixteenth-century Swan Hotel at Staines for lunch on the second day before they travel upriver as far as Abingdon-on-Thames, Oxfordshire.

DID YOU KNOW
Exceptional high river flows in 2012 made it necessary to partially cancel the Swan Upping Ceremony between Sunbury and Windsor, but the first full cancellation in its 900-year history was in 2020 due to Covid-19 social distancing measures.

Taking inspiration from the Swan Upping Ceremony, here in the riverside gardens is a superb sculpture, *The Swan Master*, created in 1983 by Diana Thomson. This larger-than-life bronze sculpture is 7-foot-tall and depicts a swan-catcher with his pole, holding a struggling swan.

Ahead of us Staines railways bridge crosses the river and even that is swan related.

DID YOU KNOW

The grey-painted Staines railway bridge with its 6.20-metre (21-foot) clearance was decorated with a yellow stripe apparently to stop swans flying into it. Swans are the largest and heaviest flying birds and over water usually fly at a height of 2–3 metres, but double this to avoid obstacles like houses.

The Swan Master by Diana Thomson in the memorial gardens.

The river looking back towards the bridge with the seventeenth-century Thames Lodge Hotel on the right.

The river with the Thames Lodge Hotel on the left and the church of St Peter.

Continuing along the Thames Path, we encounter the seventeenth-century Thames Lodge Hotel. The earliest written reference to this ancient riverside hostelry dates back to 1629 when it was aptly named The Woolpack and later The Packhorse. Wool from the West Country was brought to Staines by teams of packhorses, arriving at the Woolpack where it was transferred to barges to be taken down the Thames.

Next we pass a pair of early riverside cottages named Hook On and Shoot Off. The unusual names are from the days when barge traffic on the river used teams of horses to pull them. Here the towpath changes from one bank to the other, so just before the horses reached the cottages they were whipped into a gallop, and having built up the momentum, the tow ropes were released and the barges drifted across the river to the opposite bank. The horses would either be ferried across the river or walked over the bridge to be reconnected to their barges on the opposite bank.

Reaching the railway bridge, look for the rollers on the corner buttresses, put there to prevent the barge tow ropes rubbing grooves into the brickwork, and also to prevent the ropes from fraying. Here the river and Laleham Road almost touch, and across the road on the railway embankment is the Coal Tax Post previously mentioned.

Continuing along the Thames Path we pass the rear entrance of St Peter's Church on the Laleham Road, built in 1893/4. It was funded by local resident and benefactor, the Solicitor General of the day, Sir Edward Clarke QC, who was famous for defending Oscar Wilde at his trial.

St Peter's Church viewed across the river.

For the next half mile or so, this stretch of the riverbank became known as Houseboat Reach due to the variety of luxurious, two-storey houseboats moored there. Owned or rented by the well-to-do, these were weekend or holiday retreats complete with servants to cater for the residents. At night the boats would be illuminated with coloured lanterns as partygoers danced on the awning-protected top decks to the latest musical sounds supplied by live bands.

DID YOU KNOW
Houseboats began to appear on this stretch of the river in the 1880s. These floating palaces were well frequented by music hall stars and VIPs including Edward VII, better known as Bertie, eldest son of Queen Victoria and Prince Albert.

By 1919 the first of the riverside chalets began to appear, gaining this area the name 'bungalow town'.

Although on the opposite riverbank, the next point of interest is Truss's Island, named after Charles Truss, Clerk of Works from 1774–1810. He did so much to improve navigation on this stretch of the river that in 1804, the City Corporation set up an inscribed stone to him on this uninhabited island that took his name.

Another significant landmark on the opposite riverbank is the Fishing Temple. A keen angler, Edward VII is known to have fished from the riverbank by this temple.

The 'bungalow town' of Penton Hook, 1919.

Continue to Penton Hook, where the Thames makes a spectacular horseshoe sweep, one of the tightest along its 210-mile length. Before the lock was built in 1815, the river regularly flooded across the narrow neck. Penton Hook Lock House dates from 1814.

DID YOU KNOW
In 1952, the wives of lock-keepers were paid £3.10s a week to act as summer assistants because of the increased number of visitors using the river for recreational purposes.

In 1962, an 80-acre exhausted gravel pit was linked to the Thames at Penton Hook to form Penton Hook Marina, now the largest inland marina in Britain with 575 berths.

It's an easy walk along the towpath from Penton Hook to Laleham passing over the Intake Channel from the Thames to Queen Mary Reservoir. A very wide hosier bed stretched along the bank almost from Penton Hook to the ferry crossing at Laleham giving the village a centuries-old industry, and possibly its name as *lael* means twig and *ham* means water meadow or village.

DID YOU KNOW
Twenty million gallons of Thames water is pumped daily through the Laleham intake and along ¾ mile of open channel to the pumping station at the base of the west bank of Queen Mary Reservoir. When it was erected in 1928, it was the largest reservoir in the world. It's capable of holding some 6,700 million gallons of water, and has a surface area covering 707 acres.

Across on the opposite bank is the highly respected boatbuilding company of G. Harris. In 1849, Lord Lucan, the then owner of the land, leased 23 acres of osier land to George Harris for a term of twenty-one years at a yearly rental of £18. The tenancy continued and by 1900 the boatbuilding company was established. Soon after, G. Harris was responsible for erecting the wooden holiday chalets (now grand residential homes) along Laleham Reach.

On entering Laleham the lanes depict the character of the village with names like Blacksmith Lane, Vicarage Lane and Ferry Lane. Iron Age spearheads from the fifth century have been found in the Thames here.

As the name implies, a ferry used to cross from here to Laleham Reach, Chertsey and the popular golf course. The 4th Earl of Lucan, who owned the land at the time, had the golf course constructed in 1903 for the entertainment of his family and friends. It became

a members' club in 1907 and enjoyed widespread recognition but was plagued by the fact that the landlord had frequent consultations with a gravel-raising company eager to purchase the land. Finally, the club closed in March 2017.

Iron Age spearheads found here.

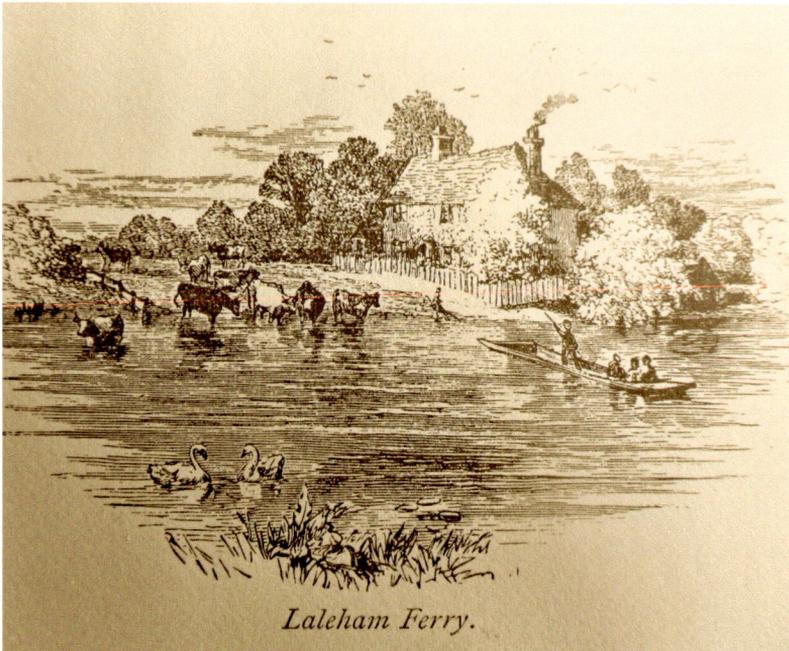

Laleham Ferry.

A picturesque view of the Laleham ferry.

DID YOU KNOW

When American actor/comedian Bob Hope was filming at Shepperton Studios he lived at Church Farm, Laleham. He and his co-star Bing Crosby were frequently ferried across the river from Laleham to the Golf Links on the opposite bank.

DID YOU KNOW

Even though the title 'ferryman' is always used, Laleham/Chertsey had a ferrywoman. In the accounts of Edward I dated 21 February 1300, it reads 'Three shillings to Sybille, the ferrywoman at Chertsey for her and six men for passing the King and his family over the Thames from Chertsey to Kingston.'

The Laleham village sign.

8. Laleham

The church of All Saints is at the heart of the village and according to legend sits on the site of a former Roman temple, although it now sits on a sharp right-angled bend where the Shepperton and Ashford roads meet. It dates from the twelfth century but was largely rebuilt in brick in around 1600 and the present tower was built in 1780. A plaque on the tower says the village was recorded in the Domesday Book of 1086.

Thirteenth-century records indicate a monastic grange and watermill on the banks of the River Thames at Laleham close to what would later be the site of Laleham Manor House. A period drawing of Chertsey Abbey on the opposite riverbank shows a quite substantial building at Laleham that no doubt survived until the Reformation when all monastic properties were confiscated by the Crown. Records show that from 1538 to 1611 King James I granted the Manor of Laleham and a property named Billetts, which undoubtedly incorporated the former monastic grange, to Henry Spiller, knighted by the king in July 1618.

The church of All Saints, Laleham, 1890.

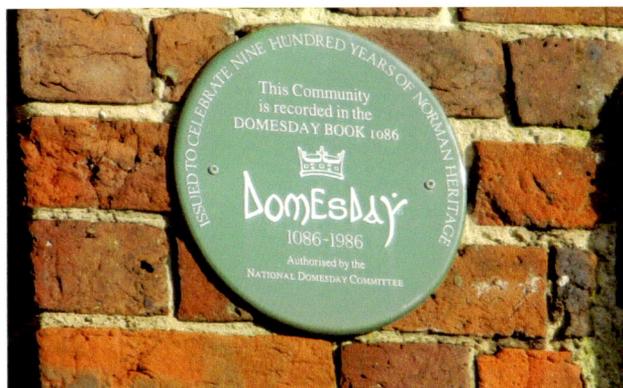

The Domesday plaque.

Fifteenth-century map of Chertsey grange, drawn to settle a dispute over pasture. Laleham grange is shown on the north bank of the river. (National archives; heritage image)

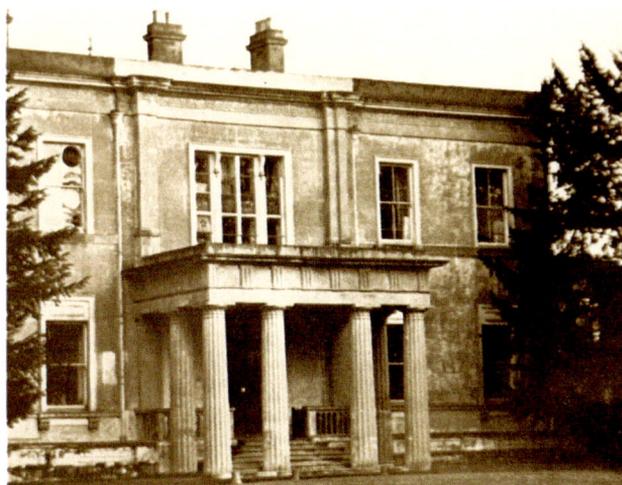

Laleham House.

Henry Spiller is first mentioned in the 1602 Domestic State Papers as informing on corrupt officials, but in 1603 he was accused of being involved in the Gun Powder Plot. When proved innocent, as compensation he was given a position in the Treasury but was soon one of the most corrupt officials in the Treasury Office and was imprisoned in the Tower of London. After his death in 1660, the manor of Laleham and Billetts passed to his daughter Katherine and her husband, Sir Thomas Reynell, and remained in the family until 1736.

DID YOU KNOW
The 1662 Hearth Tax lists the names of property owners and the number of hearths at that property. Billetts had eighteen hearths and was by far the biggest house in Laleham or Staines.

The Manor of Laleham when the first census was taken in 1801 covered an area of 1,250 acres with a population of 372. At this time and up to his death in 1803, the Lord of the Manor was William Lowther, 1st Earl of Lonsdale, but things were about to change.

The Lucans

In 1795, sixty-year-old Charles Bingham was created 1st Earl of Lucan and his wife, Margaret, became the 1st Countess. Their eldest daughter, Lavinia, married Viscount Althorp, later the 2nd Earl Spencer, the first of two members of the Lucan family from whom Diana Princess of Wales was descended.

Margaret, Countess Lucan was a writer, artist, copyist and a fine miniaturist working under the name Margaret Bingham. Her paintings, which include still lifes and landscapes, attracted the attention of the art world and were much admired. They were and still are much collected and sell at prestigious auction houses like Bonhams and Chaucers. She spent sixteen years completing miniatures and illuminations for a five-volume edition of Shakespeare's historical plays, for the library at the Spencer family seat at Althorp, Northamptonshire.

The 1st Earl died in 1799 and was succeeded by his son Richard, who in 1803 acquired the Laleham estate. The house and 800 acres of good arable pasture and meadow land was bought at auction for £20,000 by the government and was given to Richard Bingham, 2nd Earl of Lucan, in exchange for land which the Lucans owned in Ireland.

In the bill of sale of the Manor of Laleham, lot XVI also included 'the ferry across the river Thames with the Ferry House and old enclosures on the Surrey side of the water which are situated in the Parish of Laleham'. This included the previously mentioned hosier beds and land which became the Laleham golf course.

This heralded a new era for Laleham and the Lucan family, an association that lasted 125 years.

Richard Bingham, 2nd Earl of Lucan, erected the present Palladian-style house with renowned architect John Buonarotti Papworth. It has been described by Pevsner as 'compact with a Greek column porch and altogether very progressive for its date'. After the break-up of their marriage, Lady Lucan left Laleham never to return and the Earl spent very little time here. During one of his frequent spells of absence, Donna Maria II, Queen of Portugal, lived at Laleham House from 1828–29 while in exile from her homeland. It's said that her bedroom, always known afterwards as The Queen's Room, was so large it was later divided into five rooms.

In 1839, the house passed to George Charles Bingham, the 3rd Earl of Lucan, who built new stables and a model farm. In 1845, the Lucans owned three quarters of the total area of the parish of Laleham which amounted to 900 acres.

DID YOU KNOW

The 3rd Earl gained notoriety as the man who gave the fateful order to charge the Russian guns at the Battle of Balaklava during the Crimean War. The 'Charge of the Light Brigade' was a tragic blunder, from which only 195 mounted men out of 673 returned.

In 1863, the 3rd Earl built the village school and a house for the master. He died in 1888 and is buried in Laleham churchyard. Like his forefathers, the 4th Earl was keenly aware of his responsibilities to the village and gave the land for the extension of the churchyard in 1900, and in 1907, more land for the building of the village hall. But the Lucan finances were much reduced and in 1899, the 4th Earl instructed his estate agent to find a buyer for the estate. They were not successful. When he died in 1914, he was buried in the same grave as his father.

The 5th Earl (1860–1949) continued his predecessor's benefaction to the village, giving land for the recreation ground in 1922, and more land which ran alongside the Laleham House boundary to widen the towpath. He could have made a considerable amount of money if he had permitted development along the Shepperton Road, but he refused to allow that.

Instead the whole estate was offered for sale in four lots on 27 July 1922. This included Laleham House and 83 acres of land with the reserved price of £12,000. It was not met. With the estate unsold, the 5th Earl decided to sell the contents of the house and on 27 November, 652 items in eighty-three separate lots went under the auctioneer's hammer.

DID YOU KNOW

When most of the contents of Laleham House were sold in 1922 prior to the departure of the Lucans, 220 miniatures painted by Margaret, 1st Countess of Lucan, were included.

It was not until 1928 that the 5th Earl sold Laleham House. Although not a Laleham resident, the 6th Earl returned to the area in 1954 to open Matthew Arnold School (named after another famous Laleham resident).

Richard John Bingham, 7th Earl of Lucan, succeeded in 1964, and became even more notorious than his ancestor the 3rd Earl. In November 1974 when the body of his children's nanny was found, and Lucan had disappeared, the police issued a warrant for his arrest and the inquest into Sandra Rivett's death named him as her murderer – allegedly Lucan had intended to murder his wife and mistakenly murdered the nanny.

For fifty years there has been continuing interest in Lucan's fate, and hundreds of alleged sightings have been reported in various countries around the world, none of which has been substantiated. Lucan has not been found, despite a police investigation and widespread press coverage. In his absence he was declared bankrupt with debts of £45,000 and in order to release his assets thirty-three pieces of family silver were sold at auction in 1976 for £30,665. He was declared legally dead in October 1999. His only son, George Charles Bingham, became the 8th Earl. Lord Lucan opened the Lucan Pavilion and Recreation Ground in Laleham in 2001. The home of the local football team, the pavilion hosts many other sporting and social events throughout the year, and accommodates the local cafe, Cavos.

The Lucan grave in Laleham churchyard.

Laleham Park

In 1931, the estate was sold to a developer who planned to build 300 houses. It was only due to the prompt and persistent action of Laleham residents that this was thwarted. They were able to persuade Middlesex County Council and Staines Urban District Council to buy the park and preserve it for recreational purposes. In 1932, Laleham House was bought by the Community of St Peter the Apostle, giving a name change to Laleham Abbey that still persists. In 1981, Laleham Abbey was purchased by a property developer and converted into private apartments.

DID YOU KNOW
Laleham Park is still open to everyone and there are vestiges of those bygone days when the Lucans entertained lavishly. Amongst the frequent guests at Laleham House was the Prince of Wales, later King Edward VII.

A reminder of that country house lifestyle is the ice house here in the park. By the mid-seventeenth century, for the upper echelons of society, having ice in summer had become as essential as coal in winter. Ice houses were brick-lined domed pits with most of their volume underground, allowing tightly packed ice and snow harvested in the winter to stay frozen for up to eighteen months. As the ice slowly melted a drain hole in the base linked to the water source allowed it to trickle back to its watery home. The Laleham ice house would have relied upon a supply of ice from the nearby River Thames which would regularly freeze over – there's a photograph of the Laleham ferryman breaking up the river ice.

In 1911, General Electric introduced a household refrigeration unit powered by gas, making the ice house obsolete. Although the Laleham ice house is still there, apart from an informative notice board and the mound that's now thickly overgrown, there is little to see and no access.

All the produce that supplied Laleham House would have been grown in the kitchen gardens and in the 1803 sale particulars of the estate, it refers to as an ancient brick wall surrounding 'the old garden and orchard ... three garden houses, grapery and vinehouse ... the walls covered with choice fruit trees and the garden planted'. This wall containing 200,000 bricks and 900 feet of Portland stone is still in place and what makes it special are the distinctive indentations formed at intervals in the brickwork of the wall that are still visible. These housed ovens and flues where fires were built to warm the wall to encourage pleached fruit to ripen on the other side. In 1961, the Staines Urban District Council acquired the site and it's now the council nurseries where plants are propagated.

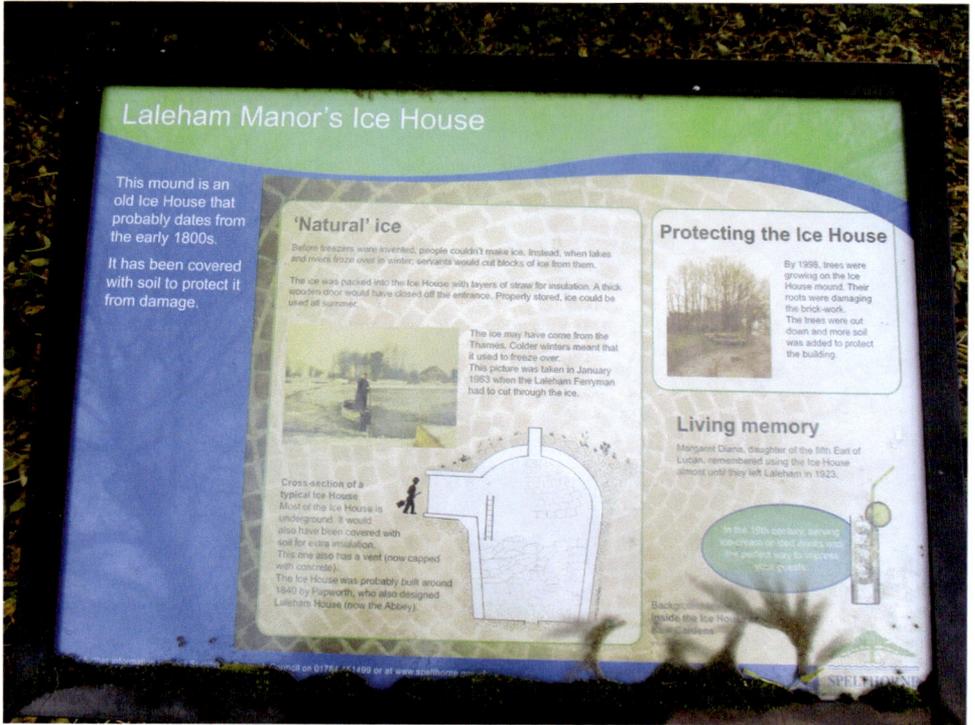

The ice house sign.

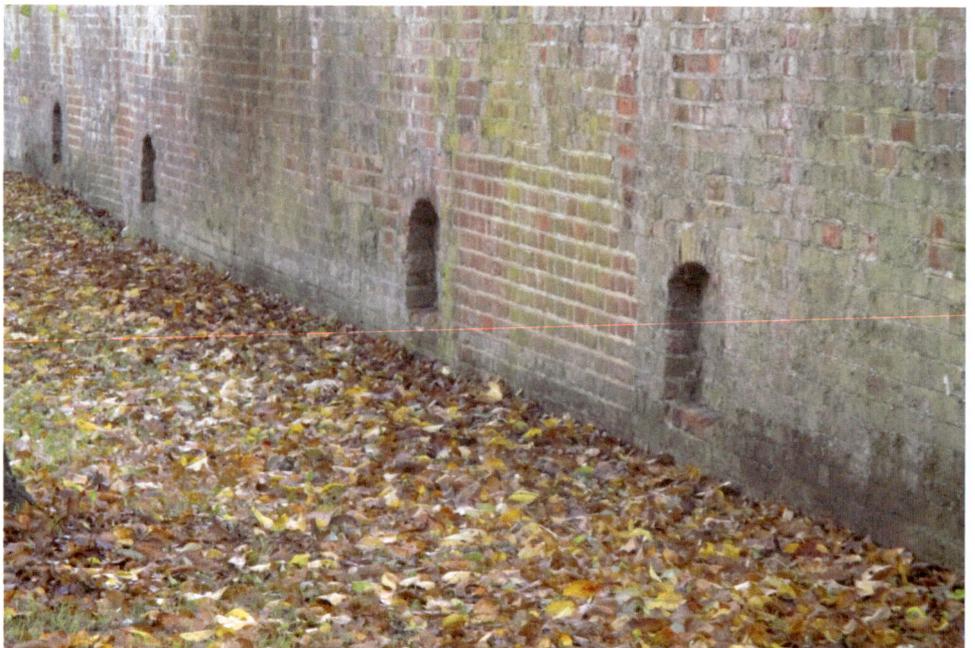

Former ovens in the garden wall.

The Cottage Orné

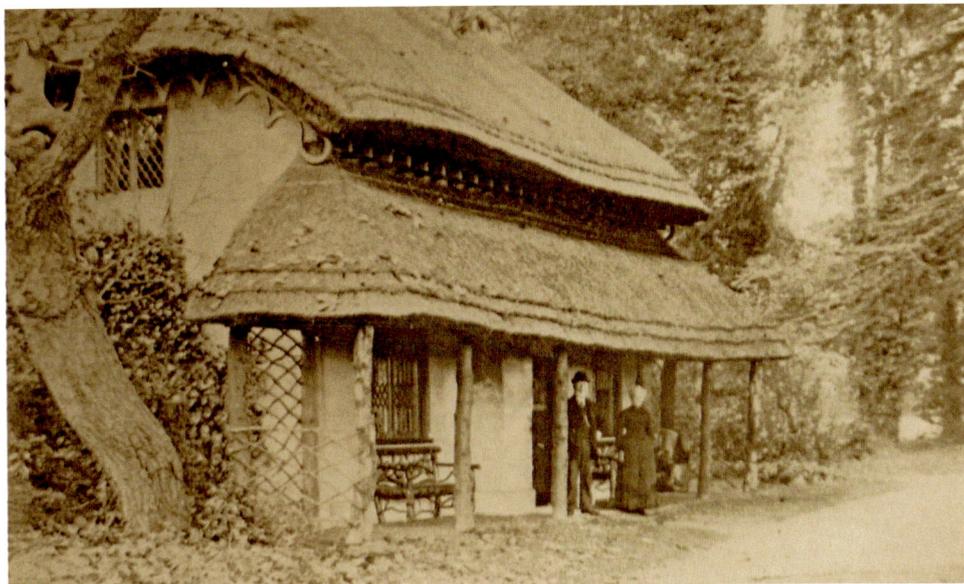

The thatched cottage orné with 100 years difference (seen overleaf).

Another delightful vestige of the country house estate is the thatched cottage orné built as a lodge in 1807 and designed by John Buanarotti Papworth, the architect of Laleham House. Cottage orné is a French term for decorated cottage or what English Heritage define as 'a rustic building of picturesque design, the archetypal "chocolate box cottage"'. The name dates back to the vogue for building rustic, stylised cottages in the late eighteenth and early nineteenth centuries, generally built by the wealthy, either as rustic retreats for themselves or as embellishments for their estates. They were not cottages in the usual sense of a small dwelling for the rural poor.

The Coverts, an early eighteenth-century, square pavilion-type house with central Doric doorcase. This is just one of twenty-five listed buildings in Laleham. The main building spurt in Laleham was during the eighteenth and nineteenth centuries, and this period has given us some fine buildings, but there are also a few buildings from the seventeenth century. Records show that part of the Three Horse Shoes in the heart of Laleham was in existence as an inn by 1624.

Muncaster House is another fine Georgian House, built around 1750 with a Victorian addition, so totally different in character added a hundred years later. At this time, the Revd John Buckland and his brother-in-law Dr Thomas Arnold were running a school here and the extension was to give extra accommodation. The Bucklands lived at Muncaster House, but Thomas Arnold, his wife Mary and six children lived in a house that was pulled down in 1864. The Old Vicarage, Glebe House and church school were built on the site. Muncaster House later became a hotel but in the 1950s was converted into eight self-contained flats.

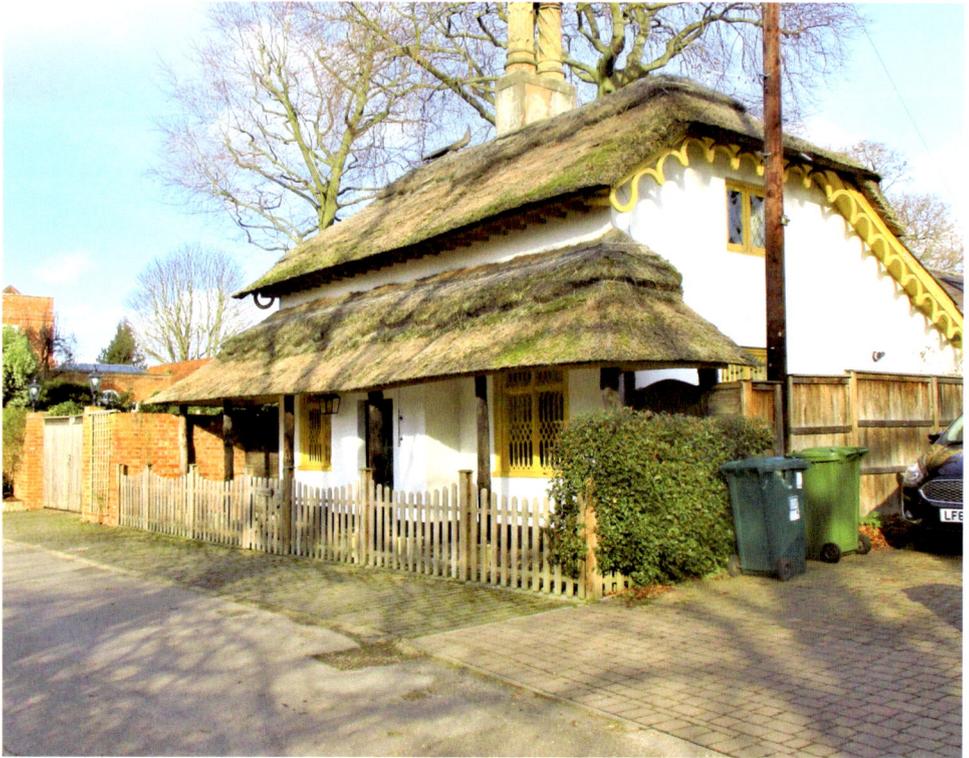

Thatched cottage today.

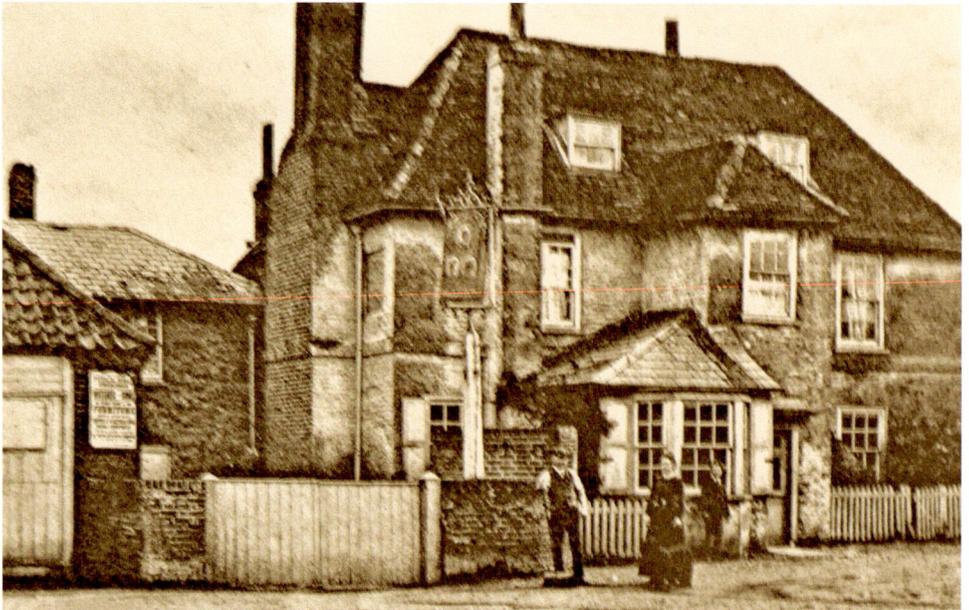

The seventeenth-century Three Horse Shoes.

The Three Horse Shoes.

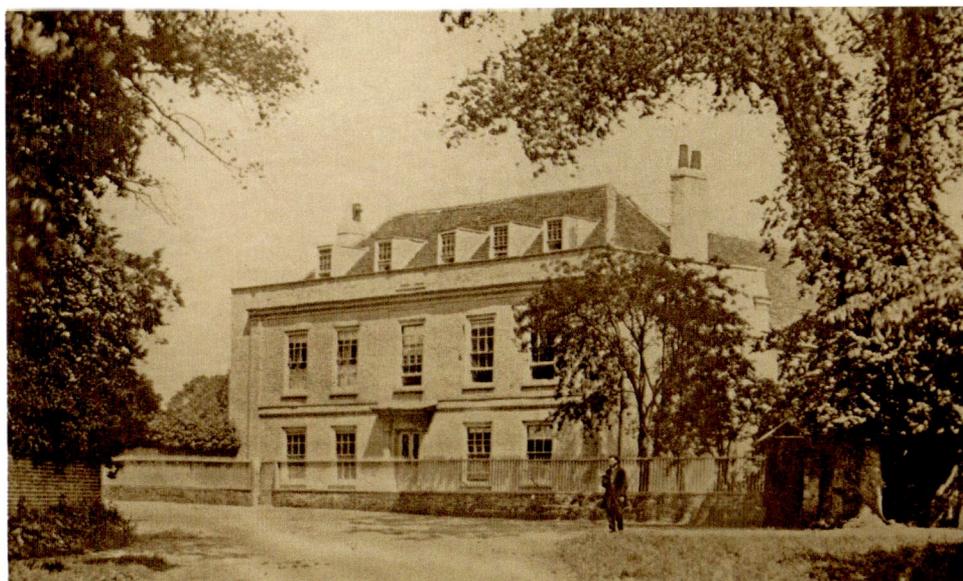

Muncaster House.

Dr Thomas Arnold became famous as the headmaster of Rugby School and has a memorial tablet in the wall of the north aisle of Laleham Church. His son Matthew, born here at Laleham, became a famous nineteenth-century poet and cultural critic who worked as an inspector of schools. The Matthew Arnold School in Kingston Road is named after him, and he is buried in the churchyard.

It's rather fitting to end with the words that Thomas Arnold wrote to a friend in September 1819 just after moving to Laleham:

> The country about us is very beautiful and some of the scenes at the junction of the heath country with the rich valley of the Thames are very striking. Or if I do not venture far from home, I have always resource at hand in the bank of the river up to Staines, which though it is perfectly flat, has yet a great charm from its entire loneliness, there being not a house anywhere near it, and the river here has none of that stir of boats and barges upon it, which makes it in many places as public as the high road.

Things have changed since Thomas Arnold wrote this, yet the walk from Laleham to Staines along the valley of the Thames has a hypnotic charm that is timeless.

Muncaster House today.